# PHOTOGRAPHY AND PHOTOGRAPHERS TO 1900

GARLAND REFERENCE LIBRARY
OF THE HUMANITIES
(VOL. 594)

# PHOTOGRAPHY AND PHOTOGRAPHERS TO 1900
*An Annotated Bibliography*

Robert S. Sennett

GARLAND PUBLISHING INC. • NEW YORK & LONDON
1985

**Library of Congress Cataloging in Publication Data**

Sennett, Robert S., 1955–
Photography and photographers to 1900.

(Garland reference library of the humanities ;
vol. 594)
Includes index.
1. Photography—Early works to 1900—Bibliography.
I. Title.  II. Series: Garland reference library of the
humanities ; v. 594.
Z7134.S46  1985  [TR145]  016.77    85-7002
ISBN 0-8240-8728-3 (alk. paper)

Cover Design by Donna Montalbano

Printed on acid-free, 250-year-life paper
Manufactured in the United States of America

# CONTENTS

Introduction                                vii

General Works                                 3

Early Technical Treatises                    23

Early Theoretical Treatises                  52

Monographs on Photographers                  53

Early Views and Topographic Surveys          98

Addendum                                    114

Index                                       117

# INTRODUCTION

> Every live photographer reads books;
> and not only reads, but studies them,
> thus becoming familiar with the wondrous
> progress of our art, and placing him-
> self in a position to intelligently
> compete with those about him.
>
> Books, as a medium of thought circu-
> lation, deserve the first place in our
> affections. For the present status of
> photography, and for the many hours
> passed in their company we should be
> truly grateful. If the world were de-
> prived of books, it would lose one of
> its most substantial joys, for they are
> a profitable pursuit of unmeasured
> pleasure.
>
> > --A.C. Austin, in PHOTOGRAPHIC
> > MOSAICS, No. 24, 1888.

Photography arrived in the nineteenth century on
the heels of the Industrial Revolution. Its appeal was
as much technological as it was esthetic, and the
early history of the medium is an endless procession
of chemical combinations and scientific research.
Despite this, it was a phenomenally popular art. Its
practitioners were to be found in every station of
life, and in every country on earth.

This unique combination of technicality and
popularity necessitated a huge body of literature
which could explain to both the professional and the
amateur the basic procedures, formulae, and philoso-
phies of the photographic processes. The demand for
books on photography which followed the appearance of
the Daguerreotype in France in 1839 continued unabated
throughout the century, even to the present day, where
it has now mixed with history.

PHOTOGRAPHY AND PHOTOGRAPHERS: AN ANNOTATED
BIBLIOGRAPHY TO 1900 is about these books. It is not
a comprehensive bibliography; such a list would run
to a ridiculous number of volumes and include much

which is totally useless to the present-day reader.
It is selective--a concise compilation of those ti-
tles which deserve recollection because they are
groundbreaking, or particularly influential, or of
historical importance, or rare, or of especial
literary merit. Also included are works published in
the twentieth century by the historians of the art
which are of interest to the photographic archivist,
student, and collector.

The path of this literature is particularly
geographic. It began in France, spread immediately
to England, flourished in the United States, and then
swelled in Germany, Italy, and the rest of the world.
The reader interested in chronicling such things will
note that the imprint dates of 1839-1850 are largely
French. To those of 1850-1860 we can add a passel of
British imprints, then many American ones, and so on
--with exceptions to be found along the way. This
journey could be likened in a loose way to the spread
of printing four centuries earlier. Both were new
technologies, heavily dependent upon technical
knowledge, extraordinarily popular, and immediately
in demand. The difference, luckily for those of us
studying photographic history today, is that the
earliest practitioners of the art left us not only
examples of their work but detailed explanations of
it. The photographic incunabulist need not conduct his
work largely in the realm of implication; the books
are available and plain to see. PHOTOGRAPHY AND
PHOTOGRAPHERS functions as a handbook to this
literature.

The standard ordering of the history of photog-
raphy is from Daguerre to Eastman with stops along
the way for each major new technology, and I have
maintained such divisions in the organization of the
work. After a section of general histories--the
large majority of which are modern works--the bibli-
ography is classified by subject, i.e. COLLODION,
DAGUERREOTYPES, etc. These technical studies are
followed by an extensive list of monographs (also
classified by subject). Lastly, there is a list of
books of views, strictly alphabetical by author. Al-
most all of these books could be reclassified, and any-
one with a question should consult the index, which
lists the books by author and subject in one
universal alphabet.

Such organization of the material is in part a
result of a reliance upon the format of the published

catalogue of the Epstean Collection at Columbia
University in New York (1937). Edward Epstean was one
of the earliest American collectors of books on
photography and his collection was one of the prime
sources of research for this book. Additionally, I
consulted the Fine Arts Library in the Fogg Art Mu-
seum at Harvard University, Cambridge, MA., and the
printed catalogue of the Library of the International
Museum of Photography in Rochester, NY. Nearly all
of the books included in this bibliography can be
found in some form in one of these collections.

It must be stressed that this work is devoted
entirely to books. The periodical literature of
photography was vast and influential and its importance
to both practitioners then and to historians now can-
not be underestimated. To include this material in
this bibliography would, however, so enlarge its scope
that use would be encumbered by it. For those inter-
ested in seeing this material, the libraries noted
above (and many others) have extensive collections
--but without a good index the reader is left with
nothing to do but browse. Consequently, I have tried
to follow and supplement this work with just such an
index, which hopefully will help remedy the situation.

Many great photographers of the nineteenth
century have not had monographs devoted to them to
date, nor did they issue texts related to their work
in their lifetimes. Thus they fail to receive their
proper due here. I have tried, whenever possible,
to mention some of these photographers at appropriate
points in the annotations and if so their names
will appear in the index, but in general only a few
dozen names qualify for their own headings due to the
specific bounty of literature by and about them.

Finally, the focus of this work is the literature
on photography in the nineteenth century. Because of
this, certain photographers whose careers began in the
nineteenth century but whose contributions more prop-
erly belong to the twentieth--such as Steichen--
have been ignored, while those who worked in the
early twentieth century but whose subject was the
documentation of the nineteenth--i.e., Atget or Cur-
tis--are included. Also, technical works published
in the 1890's but properly concerned with twentieth
century esthetics such as moving pictures or ab-
stract photography have not been included.

A few more words should be added at this point
to help the reader with the use of this book.
In selecting the collections of early views,
preference was given to works whose scope encompassed
the general rather than the specific, i.e., classified
by geographic area rather than one house, one
monument, or one city (except major cities). Also,
collections of views by a photographer whose work is
catalogued in the section of monographs are included
there and not with the early views.

A contemporary publication which includes or dis-
cusses work by a single catalogued artist is includ-
ed as a monograph in the section on that artist, but
not necessarily under the artist's name (it may be
found under the name of the author of the text). If
many artists' work is under consideration, however,
the book will be found with either the histories or
the views.

I have generally opted for the first edition of
all works, assuming these would be of the greatest
interest to the historian. Occasionally, a later
edition would be greatly expanded and in such cases
I have included it. Some works are included in the
first English translation, and in others the first
edition is noted but the annotation came from a later
and more readily available copy.

Reprints are noted whenever applicable. The his-
tory of photography was particularly well-served by
the Arno reprint series, but I have not as a matter
of course included every reprint of theirs, pre-
fering to consider the inclusion of titles on a case-
by-case basis. Anyone interested in a complete list
of the titles in this series can obtain it quite
simply by opening any one of the reprint volumes
and turning to the back, where they are completely
itemized.

Page numbers refer to the number of pages of
text. Many early books on photography contain in-
numerable pages of advertising matter and testi-
monials, and while these are amusing and even
occasionally informative, they do not help in giving
a proper indication of the length of a work.

Lastly, a word about the descriptions of the
illustrations. I have chosen the word "reproduction"
to indicate photographs reproduced on the page, the
standard form of photographic illustration in modern
times. The word "plates" refers to photographs which
have most likely been taken from original prints or
negatives, but are still on the page. The difference

between "plates" and "reproductions" is qualitative.
"Original photographs" or "original prints" means
the first edition of the work, properly complete,
includes an actual print, laid or pasted in. "Il-
lustrations" simply indicates non-photographic materi-
al, or photographs unrelated to the subject at hand.
Exceptions to these terms are noted, but they can
easily be slurred and they should be used for evalu-
ating the material for study and not a bibliographic
dictum.

The reader is again reminded that this bibliog-
raphy is only concerned with work in book form. Sets
of plates, privately printed portfolios, and off-
prints of the publications of photographic societies
are outside of its scope. If there are additional
questions as to the classification of a particular
item or subject, the index is designed to answer
those questions and should be continually consulted.

The author would like to thank the staff of the Fine
Arts Library, Harvard University, for their help,
and especially Wolfgang M. Freitag, Librarian, with-
out whose advice and support this work could not
have been completed.

# PHOTOGRAPHY AND
# PHOTOGRAPHERS TO 1900

1. Abney, William de W. A TREATISE ON PHOTOG-
RAPHY. London: Longmans, 1878.   326 pp.;
index.

After a very brief introduction to the
history of the discovery of photography,
Abney explains the chemical and physical
laws of photography and outlines the
procedures for various processes.

2. Barley, M.W. A GUIDE TO BRITISH TOPOGRAPH-
ICAL COLLECTIONS. With contributions by
P.D.A. Harvey and Julia E. Poole. Lon-
don: Council for British Archeology,
1974. 159 pp.; index.

A list of sources of illustrations of
British scenery in the form of draw-
ings, prints, and photographs. Arranged
by county, it consists primarily of
public collections, but a few private
collections are included. The photo-
graphs are generally uncredited, and
when identified they are not indexed,
so access is limited strictly by sub-
ject.

3. Bibliotheque Nationale (Paris). AFTER
DAGUERRE: MASTERWORKS OF FRENCH PHOTOG-
RAPHY (1848-1900).   Trans. by Mary S.
Eigsti. N.Y.: Metropolitan Museum of
Art, 1980. 187 pp.

A catalog of an exhibition at the Metro-
politan Museum of Art, New York, held
Dec. 18, 1980-Feb. 15, 1981, original-
ly at the Petit Palais, Paris. Includes
long articles on early French photog-
raphy by Jean-Pierre Sequin and Wes-
ton Naef and a catalog of reproductions
by Bernard Marbot. This includes exam-

ples from nearly 100 photographers such
as Negre, Nadar, LeGray, etc.

4. Boussel, Patrice. EROTISME ET GALANTERIE
   AU 19ᵉ SIECLE. Paris: Berger-Levrault,
   1979. 102 pp.

   Erotic and suggestive photographs are
   used as examples to illustrate the soc-
   ial and sexual mores of French society
   in the late 19th century. Arranged by
   general themes, i.e. "les accessoires,"
   "le spectacle," "galanterie et prosti-
   tution."

5. Browne, Turner and Partnow, Elaine. MAC-
   MILLAN BIOGRAPHICAL DICTIONARY OF PHOTO-
   GRAPHIC ARTISTS AND INNOVATORS. N.Y.:
   Macmillan, 1983. 872 pp.

   Over 1700 biographical sketches, with
   a slight predominance of 20th century
   artists. The sketches are supported by
   bibliographic citations whenever possible,
   and there is an appendix of museums and
   galleries which own and exhibit photo-
   graphs.

6. Buckland, Gail. REALITY RECORDED: EARLY
   DOCUMENTARY PHOTOGRAPHY. Greenwich, CT:
   New York Graphic Society, 1974. 128 pp.;
   bibliography, index.

   Mostly reproductions, by photographers
   known and unknown, of expeditions, wars,
   historical events, social issues, and
   famous persons.

7. Coe, Brian. THE BIRTH OF PHOTOGRAPHY. Lon-
   don: Ash & Grant, 1976. 141 pp.; biblio-
   graphy, index.

   A well-illustrated narrative history, con-
   centrating on English and American work.

8. _____. GEORGE EASTMAN AND THE EARLY
PHOTOGRAPHERS. Foreword by Roy Strong.
London: Priory Press, 1973. 96 pp.; brief
bibliography, index.

In actuality, a history of photography
from its origins to Eastman's death
(1932). Eastman himself is not mentioned
until page 55. Coe was the curator of
the Kodak Museum in Rochester, NY at the
time.

9. _____ and Haworth-Booth, Mark. A
GUIDE TO EARLY PHOTOGRAPHIC PROCESSES.
(London): Hurtwood Press, 1983. 112 pp.;
bibliography, index.

This concise but complete work con-
tains instructions on how to identify
and differentiate early processes from
physical evidence, as well as a chart
telling when each process was in peak
use, a glossary of commonly-used terms
of identification, and 37 plates which
serve as specific examples of various
processes. There is an addendum on the
care of old photographs.

10. P.& D. Colnaghi & Co. (London). PHOTOG-
RAPHY: THE FIRST EIGHTY YEARS. 27 Oct.
to 1 Dec., 1976. London: Colnaghi, 1976.
260 pp.; bibliography, index of photog-
raphers.

Although in the format of an exhibition
catalog, i.e. with numbered entries of
which only a small portion are illustra-
ted, this book provides insightful bio-
graphical information on each photograph-
er--many of which are not the subject of
separate monographs. Classified by nation-
ality and subject.

11. Crawford, William. THE KEEPERS OF LIGHT:
    A HISTORY AND WORKING GUIDE TO EARLY
    PHOTOGRAPHIC PROCESSES. Dobbs Ferry, NY:
    Morgan & Morgan, 1979. 373 pp.; bibliog-
    raphy, index, list of sources of sup-
    plies.

    A history of the technical development
    of photography and a guide to recreating
    early techniques in a modern studio.

12. Daval, Jean L. PHOTOGRAPHY: HISTORY OF
    AN ART. Trans. by R.F.M. Dexter. N.Y.:
    Skira/Rizzoli, 1982. 289 pp.

    A history of photography to the present
    day, with an emphasis on esthetics.
    Features early color and tinted illus-
    trations and makes frequent comparisons
    between photography and painting.

13. Davanne, Alphonse. LA PHOTOGRAPHIE:
    TRAITE THEORIQUE ET PRATIQUE. 2v. Paris:
    Gauthier-Villars, 1886/1888. 467, 573 pp.;
    name and subject indexes in both volumes.

    An extremely detailed and comprehensive
    description of the histories and tech-
    niques of all the photographic processes
    devised or in use in that day. Few photo-
    graphic illustrations.

14. Disderi, Adolphe. L'ART DE LA PHOTOGRA-
    PHIE. Paris: Disderi, 1862. 367 pp.

    "Even though Disderi was not in fact the
    inventor of the carte-de-visite, it was
    he who introduced and popularized it."
    -- Helmut and Alison Gernsheim, THE HISTORY
    OF PHOTOGRAPHY (See 27). Reprinted by the
    International Museum of Photography,
    Rochester, NY in 1978.

15. Dolan, Edward F., Jr. THE CAMERA. N.Y.:
    Messner, 1965. 191 pp.; bibliography,
    index.

    Written for the junior high school stu-
    dent. If you ignore the "you are there"
    tone, this book succeeds quite well in
    summarizing the history and technology
    of photography in a very direct manner.

16. Draper, John W. SCIENTIFIC MEMOIRS.
    N.Y.: Harper, 1878. 473 pp.

    A scientist and chemist, Draper (1811-
    1882) was one of the first Americans to
    experiment with photography, and was the
    first president of the American Photo-
    graphical Society. Reprinted by Arno, N.Y.
    in 1973.

17. Eder, Joseph M. HISTORY OF PHOTOGRAPHY.
    Trans. by Edward Epstean. N.Y.: Columbia
    Univ. Press, 1945. 860 pp.

    A translation of the first portions only
    of Eder's HANDBUCH (see 85). Contains
    much information on the pre-history of
    photography; almost 200 pages pass before
    Eder considers Daguerre. The expected
    emphasis is on Germans and Austrians,
    but on the whole the work is admirable
    for its scholarship and considering its
    date it must be considered a groundbreak-
    ing work in the historiography of photog-
    raphy.

18. _____, ed. QUELLENSCHRIFTEN ZU DEN
    FRUHESTEN ANFANGEN DER PHOTOGRAPHIE BIS
    ZUM XVIII JAHRHUNDERT. Halle a.d. Saale:
    Knapp, 1913. 186 pp.; name and subject
    indexes.

    Photographic reproductions of important

writings from the pre-history of photo-
graphy. Authors include Georg Fabricius,
Johann Heinrich Schulze, Giacomo Battista
Beccaria, Carl Wilhelm Seele, and others.
Imprints date from 1565 to 1777.

19. Epstean, Edward. A CATALOGUE OF THE EP-
    STEAN COLLECTION ON THE HISTORY AND
    SCIENCE OF PHOTOGRAPHY. N.Y.: Columbia
    Univ. Press, 1937. 1418 numbered entries;
    author & author/short title/subject in-
    dexes.

    Epstean's collection is one of the fullest
    and most valuable documenting the early
    technical history of photography. The
    collection is classified by subject.
    Approximately one quarter of the items
    are dated pre-1900. Reprinted with an
    introduction by Beaumont Newhall by Helios,
    Pawlet, VT in 1972.

20. Ernouf, Alfred. LES INVENTEURS DU GAZ ET
    DE LA PHOTOGRAPHIE: LEBON D'HUMBERSIN,
    NICEPHORE NIEPCE, DAGUERRE. Paris:
    Hachette, 1877.  191 pp.

    Ernouf wrote a series of books on famous
    French inventors. This work originally
    appeared as articles in LA REVUE DE FRANCE
    and LE CORRESPONDANT. Lebon d'Humbersin is
    credited with inventing the gaslight.

21. Fabre, Charles. TRAITE ENCYCLOPEDIQUE DE
    PHOTOGRAPHIE. 7v. Paris: Gauthier-Villars,
    1889-1902. Each vol. paginated separately.

    Long articles on every aspect of the tech-
    nology of photography. Many of the arti-
    cles are supported by bibliographic cita-
    tions. There is an index at the end of the
    4th vol. and in each of the three supple-
    ments which followed. Illustrated with
    engravings.

22. Frank, Hans. VOM ZAUBER ALTER LICHT-BIL-
    DER: FRUHE PHOTOGRAPHIE IN OSTERREICH,
    1840-1860. Wien: Molden, 1981. 112 pp.;
    bibliography.

    A history of early photography in Austria.
    Includes views, portraits, tinted and
    colored plates, photographs of equipment,
    and early advertisements. An appendix
    lists the names and locations of approx-
    imately 400 photographers; any informa-
    tion known about them is also provided.

23. Freund, Gisele. LA PHOTOGRAPHIE EN FRANCE
    DU DIX-NEUVIEME SIECLE: ESSAI DE SOCIO-
    LOGIE ET D'ESTHETIQUE. Paris: Monnier,
    1936. 154 pp.; bibliography.

    Includes illustrations from contemporary
    journals such as advertising copy and
    photographic portraits of prominent French-
    men of the day.

24. _____. PHOTOGRAPHY & SOCIETY.
    Boston: Godine, 1980. 231 pp.; index.

    A translation of PHOTOGRAPHIE ET SOCIETE
    (1974), which is a revised edition of the
    author's LA PHOTOGRAPHIE EN FRANCE with
    additional material on contemporary issues
    in photography throughout the world.

25. Gassan, Arnold. A CHRONOLOGY OF PHOTOG-
    RAPHY. Athens, OH: Handbook Co., 1972.
    373 pp.; bibliography.

    A general history treated by genre, fol-
    lowed by a chronology paralleling events
    in the history of photography with those
    occurring in the world of art and society
    in general. An index of names can be
    found at the end of the survey section
    of the book.

26. Gernsheim, Helmut. INCUNABULA OF BRITISH
    PHOTOGRAPHY; A BIBLIOGRAPHY OF BRITISH
    PHOTOGRAPHIC LITERATURE, 1839-75. London
    and Berkeley: Scholar, 1984. 160 pp.

    "...an essential reference work for any-
    one interested in 19th century British
    photography and its applications (and)
    an important milestone in the mapping
    process which heralds the coming of age
    of photo-historical research."
    --Steven F. Joseph, review in HISTORY
    OF PHOTOGRAPHY, Jan.-March, 1985.
    1261 entries. Includes books illustrated
    with original photographs.

27. _____ and Alison. THE HISTORY
    OF PHOTOGRAPHY, FROM THE EARLIEST USE OF
    THE CAMERA OBSCURA IN THE ELEVENTH CEN-
    TURY UP TO 1914. London: Oxford Univ.
    Press, 1955.

    The best general history in English--com-
    plete despite the lack of extensive detail,
    with a good balance of biographies, tech-
    nological description, and historical
    overview.
    A concise edition was published by Gros-
    set and Dunlap, N.Y. in 1965. Revised
    editions published by Thames and Hudson,
    London, in 1969 and 1982.

28. Gilardi, Ando. STORIA SOCIALE DELLA FOTO-
    GRAFIA. Milano: Feltrinelli, 1976. 461 pp.;
    extensive bibliography of 19th century
    texts and index of names and techniques.

    A history of the invention and development
    of photography in Europe and America and
    its relationship to the social changes
    caused by the Industrial Revolution. Of
    special note is the dictionary of terms
    and persons. The bibliography is also good.

29. Gilbert, George. PHOTOGRAPHY: THE EARLY
    YEARS; A HISTORICAL GUIDE FOR COLLECTORS.
    N.Y.: Harper & Row, 1980. 181 pp.

    An illustrated history of photography from
    an American point of view. Appendices in-
    clude excellent, concise explanations of
    various photographic processes and a dic-
    tionary of terms.

30. Goldberg, Vicki, ed. PHOTOGRAPHY IN PRINT:
    WRITINGS FROM 1816 TO THE PRESENT. N.Y.:
    Simon & Schuster, 1981. 570 pp.; index.

    A collection of edited writings on photog-
    raphy from Niepce through the 20th cen-
    tury, with brief introductory annotations.
    The date in the title refers to the sub-
    ject matter, not the imprint.

31. Goldschmidt, Lucian and Naef, Weston J.
    THE TRUTHFUL LENS: A SURVEY OF THE PHOTO-
    GRAPHICALLY ILLUSTRATED BOOK, 1844-1914.
    N.Y.: The Grolier Club, 1980. 241 pp.;
    bibliography, index.

    An essay on the history of photographically
    illustrated books, followed by a catalog
    of 172 reproductions in chronological
    order. A bibliography of the books from
    which the reproductions were taken, clas-
    sified in alphabetical order under the
    name of the author (not the photographer)
    is appended to the catalog.

32. Guerronnan, Anthony. DICTIONNAIRE SYNO-
    NYMIQUE FRANCAIS, ALLEMAND, ANGLAIS,
    ITALIEN ET LATIN DES MOTS TECHNIQUES ET
    SCIENTIFIQUES EMPLOYES EN PHOTOGRAPHIE.
    Paris: Gauthier-Villars, 1895. 175 pp.;
    indexes for each language.

    Part I: A dictionary list of photographic

terms in French, with a list of synonyms
in German, English, Italian, and Latin.
Part II: A table of the same terms in five
separate alphabets, one for each language,
with page references.

33. Gutman, Judith M. THROUGH INDIAN EYES.
N.Y.: Oxford Univ. Press/International
Center for Photography, 1982. 198 pp.;
bibliography, index.

A thorough, well-documented history of the
growth of photography in India to around
1920. With many reproductions, some color.

34. Hammond, John H. THE CAMERA OBSCURA: A
CHRONICLE. Bristol (Eng.): Hilger, 1981.
182 pp.; bibliography, index.

A century-by-century account of the camera
obscura, from the earliest recorded history
to the present day. Nearly 100 illustrations

35. Hannavy, John. A MOMENT IN TIME: SCOTTISH
CONTRIBUTIONS TO PHOTOGRAPHY. Glasgow:
Third Eye Centre, 1983.  82 pp.; bibliog-
raphy, index.

Published in conjunction with an exhibition
at the Third Eye Center. Views, portraits,
and cartes-de-visites by Scottish photog-
raphers, taken around the world. Repro-
duces many images which may not be avail-
able elsewhere (i.e. the photographers
are not well-known).

36. Harrison, W. Jerome. A HISTORY OF PHOTOG-
RAPHY, WRITTEN AS A PRACTICAL GUIDE AND
AN INTRODUCTION TO ITS LATEST DEVELOPMENTS.
N.Y.: Scovill, 1887. 136 pp.

A standard history, interspersing techno-
logical developments and biographical
sketches. Reprinted by Arno, N.Y. in 1973.

37. Haworth-Booth, Mark, ed. THE GOLDEN AGE
    OF BRITISH PHOTOGRAPHY, 1839-1900.
    Millerton, NY: Aperture, 1984. 189 pp.;
    index.

    A catalogue of a travelling exhibition
    organized by the Victoria and Albert
    Museum and the Alfred Steiglitz Center
    at the Philadelphia Museum of Art. The
    catalogue is divided into sections of
    general subjects, such as "The calotype
    era," "The grand tour," or "Street life,"
    and representative works from artists
    working in that genre are included,
    along with a brief introduction or
    essay on the topic. The plates are
    excellently chosen and produced and the
    selection of photographs includes all
    the chief names in British photographic
    history, and a few less-known but
    equally worthy ones.

38. Jenkins, Reese V. IMAGES AND ENTERPRISE:
    TECHNOLOGY AND THE AMERICAN PHOTOGRAPHIC
    INDUSTRY, 1839-1925. Baltimore and Lon-
    don: Johns Hopkins Univ. Press, 1975.
    371 pp.; index.

    A history of the growth and expansion
    of photography in America seen through
    the work of its business pioneers: Ed-
    ward and Henry T. Anthony, James and
    William Scovill, George Eastman, Thomas
    H. Blair, and others. Many illustrations.

39. Jones, Bernard E., ed. CASSELL's CYCLO-
    PEDIA OF PHOTOGRAPHY. London: Cassell,
    1911. 572 pp.

    A dictionary list of terms with articles
    of various lengths, from one sentence to
    several paragraphs. Names generally are
    not included. No bibliographic support.
    Reprinted by Arno, N.Y. in 1973.

40. Ken, Alexandre. DISSERTATIONS HISTO-
    RIQUES, ARTISTIQUES ET SCIENTIFIQUES
    SUR LA PHOTOGRAPHIE. Paris: Librarie
    Nouvelle, 1864. 246 pp.

    An early attempt to place photography
    in the context of artistic theory:
    mystic considerations, perceptions of
    reality, art vs. science, and so on.
    Reprinted by Arno, N.Y. in 1979.

41. La Blanchere, Henri M. de la. REPER-
    TOIRE ENCYCLOPEDIQUE DE PHOTOGRAPHIE.
    6v. Paris: Bureau de la Redaction (V.
    1-4)/ Aymot (V. 5-6), (1862)-1866.
    Each volume paginated separately;
    index.

    A list of terms with brief definitions.
    The items are numbered, with references
    made to the original sources. The
    material is arranged in several
    alphabets, so it is necessary to
    check the indexes frequently.

42. Lecuyer, Raymond. HISTOIRE DE LA PHOTO-
    GRAPHIE. Paris: S.N.E.P.-Illustration,
    1945. 452 pp.; extensive bibliography,
    index.

    The standard, chronological text is
    augmented by innumerable reproductions,
    many not readily found in other sources.

43. Marder, William and Estelle. ANTHONY:
    THE MAN, THE COMPANY, THE CAMERAS; AN
    AMERICAN PHOTOGRAPHIC PIONEER. Edited
    by Robert G. Duncan. Foreword by
    Beaumont Newhall. Amesbury, MA: Pine
    Ridge Pub. Co., 1982. 384 pp.; bibliog-
    raphy, index.

A pioneering work, of sorts--the first full-scale biography of a figure in the history of the business of photography. Good, extensive illustrations.

44. Mathews, Oliver. EARLY PHOTOGRAPHS AND EARLY PHOTOGRAPHERS: A SURVEY IN DICTIONARY FORM. London: Redminster, 1973. 198 pp.; bibliography.

An excellent source of biographical information on photographers from all of Europe and America. Includes a short dictionary of general terms and a price guide to current (1973) sales. More than half the book is given to reproductions.

45. Mayer et Pierson. LA PHOTOGRAPHIE CONSIDEREE COMME ART ET COMME INDUS-TRIE. Paris: Hachette, 1862. 244 pp.

Mayer and Pierson was one of the most important commercial photographic firms in Paris.

46. Newhall, Beaumont. THE HISTORY OF PHOTOGRAPHY FROM 1839 TO THE PRESENT. Completely revised and enlarged ed-ition. N.Y.: Museum of Modern Art, 1982; distrib. by the New York Graphic Society, Boston. 319 pp.; bibliography, index.

The latest edition of this extremely well-written history contains more text, more illustrations, and more detail than the previous four. It is equally valuable to the general reader or the student of photography.

47. _____, ed. PHOTOGRAPHY:
ESSAYS & IMAGES. ILLUSTRATED READINGS
IN THE HISTORY OF PHOTOGRAPHY. N.Y.:
Museum of Modern Art, 1980; distrib.
by the New York Graphic Society,
Boston. 327 pp.; index.

The concept is the same as Vicki Gold-
berg's PHOTOGRAPHY IN PRINT (see 30),
but there are more illustrations and
there is a greater proportion of mater-
ial dedicated to the 19th century.

48. Ovenden, Graham, ed. PRE-RAPHAELITE
PHOTOGRAPHY. London: Academy, 1984.
84 pp.

Reproductions of photographs--mostly by
Cameron and Carroll--viewed in compari-
son with contemporary paintings by Ros-
setti, Millet, and others.

49. _____. VICTORIAN EROTIC PHOTO-
GRAPHY. N.Y.: St. Martin's Press, 1973.
Unpaginated.

Mostly photographs, almost entirely of
female nudes, many anonymous, some from
erotic postcards.

50. Peters, Ursula. STILGESCHICHTE DER FOTO-
GRAFIE IN DEUTSCHLAND, 1839-1900. Koln:
DuMont, 1979. 424 pp.; with a 26 pp.
bibliography, index.

A major critical study, containing over
400 reproductions. Includes separate chap-
ters on portrait photography, landscapes,
documentary photography, and art photog-
raphy. The bibliography is classified
by subject and includes references to
many German photographers not documented
in other sources.

51. Potonniee, Georges. HISTOIRE DE LA DECOU-
    VERTE DE LA PHOTOGRAPHIE. Paris: Montel,
    1925. 319 pp.

    Trans. by Edward Epstean and published
    by Tennant & Ward, N.Y. in 1936. Par-
    ticularly valuable for its research into
    the pre-history of photography and its
    detailed analysis of the relationship
    between Niepce and Daguerre. The English
    edition was reprinted by Arno, N.Y. in
    1973.

52. Price, Lake. A MANUAL OF PHOTOGRAPHIC
    MANIPULATION. London: Churchill, 1858.
    256 pp.; brief index.

    A basic technical manual, written with
    the amateur audience in mind. The
    second edition of 1868 was reprinted
    by Arno, N.Y. in 1973.

53. Pritchard, H. Baden. ABOUT PHOTOGRAPHY
    AND PHOTOGRAPHERS: A SERIES OF ESSAYS
    FOR THE STUDIO AND STUDY. N.Y.: Scovill,
    1883. 220 pp.

    Short essays on topics of interest to
    professional photographers, i.e. posing
    groups, work and wages, pupils, business
    tact, etc. Reprinted by Arno, N.Y. in
    1973.

54. _____. THE PHOTOGRAPHIC
    STUDIOS OF EUROPE. London: Piper & Carter,
    1882. 279 pp.; index.

    A survey of the organization of photog-
    raphers' studios, mostly in England,
    with approximately one third of the book
    devoted to Scotland, France, and Germany.
    In addition to an index of names, the
    author prefaces his work with an index

of subjects, so the reader can readily
compare and examine specific operations
throughout several studios. Reprinted
by Arno, N.Y. in 1973.

55. Quennell, Peter. VICTORIAN PANORAMA:
A SURVEY OF LIFE AND FASHION FROM
CONTEMPORARY PHOTOGRAPHS. London: Bats-
ford, 1937. 120 pp.; index.

A history of social life in Victorian
England, illustrated with over 150
photographs.

56. Rodgers, H.J. THIRTY-THREE YEARS UNDER
A SKYLIGHT. Hartford, CT: Rodgers, 1872.
235 pp.

A corny, light-hearted narrative of
one American photographer's life and
times. Reprinted by Arno, N.Y. in 1973.

57. Root, Marcus A. THE CAMERA AND THE PEN-
CIL. Philadelphia: Root, 1864. 456 pp.

"...the first history of photography
to be published in the United States."
   --William Welling, PHOTOGRAPHY IN
AMERICA (see 72). Reprinted with an
introduction by Beaumont Newhall by
Helios, Pawlet, VT in 1971. From New-
hall's introduction: "Unlike all pre-
vious American publications on photog-
raphy, THE CAMERA AND THE PENCIL was
not planned as a technical treatise
but as a guide book to the artistic
aspects of photography."

58. Snelling, Henry H. A DICTIONARY OF THE
PHOTOGRAPHIC ART. N.Y.: Snelling, 1854.
235 pp.

"This work, as its title imports, is

valuable to the photographic artist
as a work of reference, and to the
student as a complete guide to the
purchase and use of all the appliances
of the art."
--THE PHOTOGRAPHIC AND FINE ART JOUR-
NAL, Nov., 1854.

59. _____. HISTORY AND PRACTICE OF
THE ART OF PHOTOGRAPHY. N.Y.: Putnam,
1849. 139 pp.; appendix, index.

"...considered the first American book
on photography until attacked in 1973
as having been largely plagiarized from
an earlier work by Fisher (see 88).
Reprinted with an introduction by
Beaumont Newhall by Morgan & Morgan,
Hastings-on-Hudson, NY in 1970.

60. Societe Francaise de Photographie
(Paris). CATALOGUE DE LA BIBLIOTHEQUE.
Paris: Gauthier-Villars, 1896. 56 pp.

Established in Nov., 1854, and still
active today, it is the second oldest
continuing photographic society in
the world (after the Photographic So-
ciety of London).

61. Sougez, Emmanuel. LA PHOTOGRAPHIE: SON
HISTOIRE. Paris: Les Editions de
l'Illustration, 1968. 218 pp.

Most of the text is concerned with the
history of photography in France. Num-
erous reproductions.

62. Stapp, William F. ROBERT CORNELIUS:
PORTRAITS FROM THE DAWN OF PHOTOGRAPHY.
Washington, D.C.: Smithsonian Institu-
tion Press, 1983. 152 pp.; bibliography.

A catalogue of an exhibition held at
the National Gallery from Oct. 20, 1983
to Jan. 22, 1984. Cornelius (1809-1893)
reportedly jumped in front of his camera
in Philadelphia in late 1839, and the
daguerreotype which resulted from this
"is believed to be the earliest sur-
viving photograph  of a human being."
(William Welling, PHOTOGRAPHY IN AMERICA.)

63. Sutton, Thomas and Worden, John. DIC-
    TIONARY OF PHOTOGRAPHY. London: Sampson
    Low, 1858. 423 pp.

    According to Gernsheim (see 27), this
    was the first dictionary of photography.

64. Stenger, Erich. DIE BEGINNENDE PHOTO-
    GRAPHIE IM SPIEGEL VON TAGESZEITUNGEN
    UND TAGEBUCHERN. Wurzburg: Triltsch,
    1949. 138 pp.; index.

    A careful exposition of the develop-
    ment of photography in Germany and
    Switzerland, with frequent quotations
    from contemporary correspondence and
    documents.

65. Strasser, Alex, ed. VICTORIAN PHOTOG-
    RAPHY. London/N.Y.: Focal Press,
    1942. 119 pp.

    A good essay on every aspect of photog-
    raphy in England from Talbot to Co-
    burn, with forty pages of reproductions
    and a biographical appendix.

66. Taft, Robert. PHOTOGRAPHY AND THE
    AMERICAN SCENE. N.Y.: Macmillan, 1938.
    546 pp.; bibliography, index.

    A self-described "social history,"
    discussing the history and technology
    of photography as it specifically

affected the American culture. Reprin-
ted by Dover, N.Y. in 1964.

67. Thomas, Alan. TIME IN A FRAME: PHOTOG-
RAPHY AND THE NINETEENTH-CENTURY MIND.
N.Y.: Schocken, 1976. 171 pp.; bibliog-
raphy, index.

An extended essay about what photographs
can tell us about travel, portraiture,
fashion, and social problems in the
19th century, primarily in England and
the United States.

68. Tissandier, Gaston. A HISTORY AND HAND-
BOOK OF PHOTOGRAPHY. Trans. by John
Thomson. London: Sampson Low, 1876.
326 pp.

Not a technical treatise but an in-
vestigation of the history and basic
theories of several photographic pro-
cesses not usually discussed outside
of specialists in the field, i.e.
microphotography, astronomical photog-
raphy, stereoscopes, etc. The parts
of the book on the origin and develop-
ment of photography are standard.

69. _____. LA PHOTOGRAPHIE EN
BALLON. Paris: Gauthier-Villars, 1886.
45 pp.

"...an account of the various aerial
expeditions that have been undertaken.
The book is full of the most interest-
ing and entertaining experiences, and
contains very clear accounts of the
difficulties encountered by the aero-
nauts in the various expeditions."
   --ANTHONY'S PHOTOGRAPHIC JOURNAL,
   Nov. 13, 1886.

70. Wall, Edward J. THE DICTIONARY OF
    PHOTOGRAPHY FOR THE AMATEUR AND PRO-
    FESSIONAL PHOTOGRAPHER. N.Y.: Anthony,
    1889. 237 pp.

    "The articles commence with Aberration
    and end with Zincography, and there is
    hardly a single thing about photography
    that a photographer may want to know
    that he will not find somewhere between
    the two."
      --ANTHONY'S PHOTOGRAPHIC JOURNAL,
    1889.

71. Welling, William B. A COLLECTOR'S GUIDE
    TO NINETEENTH CENTURY PHOTOGRAPHS. N.Y.:
    Macmillan, 1976. 204 pp.; bibliography.

    A catalogue of types of collectable
    photographica with illustrated exam-
    ples, followed by a list of books and
    journals and a list of English, Scot-
    tish, and American photographers and
    the names and addresses of photographic
    archives, libraries, and societies,
    primarily in England and the United
    States.

72. _____. PHOTOGRAPHY IN
    AMERICA: THE FORMATIVE YEARS, 1839-
    1900. N.Y.: Crowell, 1978. 431 pp.;
    brief bibliography, index.

    An excellent, detailed history of the
    growth of photography in America, with
    many quotations from original sources
    and extensive biographical information
    on many known and less-known artists.

73. Werge, John. THE EVOLUTION OF PHOTOG-
    RAPHY. London: Piper & Carter, 1890.
    312 pp.

A memoir of the author's personal
involvement with the expansion of
photography in England. (He was a
businessman). Reprinted by Arno, N.Y.
in 1973.

74. Wilson, Edward L. WILSON'S PHOTO-
GRAPHICS. Philadelphia: Wilson,
1881. 366 pp.; index.

A textbook of both technical and
theoretical photographic work, i.e.
chapters on managing a model and
naturalistic photography as well
as standard emulsions, etc. Reprinted
by Arno, N.Y. in 1973.

75. Wolf, Daniel, ed. THE AMERICAN SPACE:
MEANING IN NINETEENTH-CENTURY LAND-
SCAPE PHOTOGRAPHY. Middletown, CT:
Wesleyan Univ. Press, 1983. 122 pp.

A short essay by Wolf on the esthe-
tics of early American landscape
photography is followed by over one
hundred excellently produced plates.

EARLY TECHNICAL TREATISES

76. Anderson, Elbert. THE SKYLIGHT AND
THE DARKROOM. Philadelphia: Benerman &
Wilson, 1872. 220 pp.

The PHOTOGRAPHIC NEWS claimed this
book "ought to grace every photogra-
pher's library."

77. Batut, Arthur. LA PHOTOGRAPHIE AERIENNE
PAR CERF-VOLANT. Paris: Gauthier-Villars,

1890. 74 pp.

A brief introduction to aerial photog-
raphy, with descriptions of the
special apparatus and special photo-
graphic procedures necessary for the
work.

78. Belloc, Auguste. LES QUATRE BRANCHES
DE LA PHOTOGRAPHIE: TRAITE COMPLET
THEORIQUE ET PRATIQUE DES PROCEDES DE
DAGUERRE, TALBOT, NIEPCE DE SAINT VIC-
TOR ET ARCHER. Paris, chez l'auteur,
1855. 412 pp.; folding chart.

Concise analysis of the history,
esthetics, and techniques of the
earliest methods of photography.

79. Buehler, Otto. ATELIER UND APPARATEN
DER PHOTOGRAPHEN. Weimar: Voigt, 1867.
367 pp.; atlas of 17 plates.

Not available for annotation.

80. Chevalier, Charles. GUIDE DU PHOTO-
GRAPHE. Paris: Chevalier, 1854.

In three parts; I. Description et
emploi raisonne des instruments
d'optique. II. Nouveau memoires et
reseignments sur les moyens d'obtenir
de belles epreuves. III. Documents
historiques.

81. _____, ed. RECUEIL DE
MEMOIRS ET DE PROCEDES NOUVEAUX
CONCERNANT LA PHOTOGRAPHIE. Paris:
Chevalier, 1847. 266 pp.

Reproduces the complete texts and
extracts of letters and other docu-
ments which concern methods of im-
proving the daguerreotype process.

82. Coale, George B. MANUAL OF PHOTOGRAPHY.
    Philadelphia: Lippincott, 1858. 81 pp.

    "This appears to be the earliest manual
    prepared in the United States for the
    amateur market."
     --William Welling. PHOTOGRAPHY IN
    AMERICA (see 72).

83. Dallmeyer, Thomas R. TELEPHOTOGRAPHY:
    AN ELEMENTARY TREATISE. N.Y.: Longmans,
    1899. 147 pp.

    Dallmeyer probably invented the first
    telephoto lens (1891), and this work
    was among the first monographs on the
    subject.

84. Delamotte, Philip H. THE PRACTICE OF
    PHOTOGRAPHY. London: Cundall, 1853.
    150 pp.

    A standard textbook, quite popular in
    its day. The author gained further fame
    for his photographs of the Great Ex-
    hibition of 1851 and the Crystal
    Palace. Reprinted by Arno, N.Y. in
    1973.

85. Eder, Joseph M., ed. AUSFUHRLICHES
    HANDBUCH DER PHOTOGRAPHIE. 4v.
    Halle a.d. Saale: Knapp, 1884-
    1896.

    A massive history of the invention of
    photographic processes. Highly techni-
    cal, with a justifiable emphasis
    on German and Austrian scientific
    contributions.

86. _____ . DIE MOMENT-PHOTO-
    GRAPHIE IN IHRER ANWENDUNG AUF KUNST
    UND WISSENSCHAFT. Halle a.d. Saale:

Knapp, 1886. 2 ed. 196 pp.; index.

The art and technique of instantaneous photography, with nearly 200 engraved illustrations.

87. Finley, Marshall and Humphrey, Samuel D. A SYSTEM OF PHOTOGRAPHY. Canandaigua, NY: Ontario Messenger, 1849. 81 pp.

   "One of the first books on photography in America...printed on the press of the local newspaper."
   --William Welling. PHOTOGRAPHY IN AMERICA.
   The second ed., also 1849, was published in Albany without Finley's credit.

88. Fisher, George T. PHOTOGENIC MANIPULATION. Philadelphia: Carey and Hart, 1845. 50 pp. (part I), 48 pp. (part II).

   A rare early treatise. The first ed. was published in London in 1843 (part I) and 1845 (part II).

89. Gaudin, Marc A. TRAITE PRATIQUE DE PHOTOGRAPHIE. Paris: Dubochet, 1844. 248 pp.

   An early work by the French daguerreotypist who was one of the first to attempt to record movement.

90. Geymet, Theophile. TRAITE PRATIQUE DES EMAUX PHOTOGRAPHIQUES. Paris: Gauthier-Villars, 1885. 161 pp.

   This is the third ed. "The book has been entirely revised in this last edition, and is filled with the most useful and practical information... It is a veritable practical treatise

on the subject of photography on
enamels."
-- ANTHONY'S PHOTOGRAPHIC JOURNAL,
Oct. 9, 1886.

91. Gioppi, Luigi. LA FOTOGRAFIA SECONDO I
PROCESSI MODERNI. Milano: Hoepli, 1891.
726 pp.; index, extensive bibliography.

A guide to the procedures of photographic
technique. One of the earliest works on
photography in Italian. Especially valu-
able is the 24 pp. bibliography and the
list of photographic societies and
journals throughout Europe and America
(although without dates or addresses).

92. Halleur, G.C. THE ART OF PHOTOGRAPHY.
Trans. by G.L. Strauss. London: Weale,
1854. 108 pp.

A simple, well-written introduction to
the chemistry of photography.

93. Herschel, John F. ON CERTAIN IMPROVEMENTS
ON PHOTOGRAPHIC PROCESSES. London:
Taylor, 1843. 6 pp.

"Herschel's photographic researches are
concentrated within the first few years
after the discovery of photography, and
the genius and energy which he displayed
were overwhelming...Herschel had achieved
independently what had taken others years
to accomplish."
--Helmut and Alison Gernsheim. THE
HISTORY OF PHOTOGRAPHY (see 27).

94. Hockin, John B. PRACTICAL HINTS ON
PHOTOGRAPHY. London: Hockin, 1860.
167 pp.

"...a new and complete edition of 'hints'

from the pen of one so well-versed in
the theory and practice of our art as
Mr. Hockin is will be welcomed by every
photographer. The tyro may be at once
initiated by it into the present ec-
lectic practice of the art, while the
adept may derive some useful hints, and
become confirmed and assured in that
which yields the best results...this is
as complete a work on the subject of
photography as any extant..."
-- THE PHOTOGRAPHIC NEWS, July 27, 1860.

95. Hunt, Robert. A POPULAR TREATISE ON THE
ART OF PHOTOGRAPHY. Glasgow: Griffin,
1841. 96 pp.

Reprinted in facsimile with an intro-
duction and notes by James Y. Tong,
Ohio Univ. Press, Athens, OH, 1973.
According to Mr. Tong, Hunt, Herschel,
and Talbot "are probably the three most
important English pioneers in photog-
raphy," and this title "was the first
general manual on photography ever
published in English."

96. _____. RESEARCHES ON LIGHT.
London: Longmans, 1844. 303 pp.; index.

A scientific study on the action and
effect of solar rays upon the various
chemicals used in photography, and also
upon organic substances, such as vege-
tables and flowers. Reprinted by Arno,
N.Y. in 1973.

97. LaBlanchere, Henri M. de. L'ART DU
PHOTOGRAPHIE. Paris: Aymot, 1859. 280 pp.

An introduction to current photographic
processes. See also item 41.

98. Lea, Mathew C. A MANUAL OF PHOTOGRAPHY.
Philadelphia: Benerman & Wilson, 1868.
336 pp.

"Lea was one of the foremost authorities
on photochemistry in the 19th century,
and his MANUAL was long considered a stan-
dard work among photographers."
--William Welling. PHOTOGRAPHY IN
AMERICA (see 72).

99. LeBon, Gustave. LES LEVERS PHOTOGRAPH-
IQUES ET LA PHOTOGRAPHIE EN VOYAGE. 2v.
Paris: Gauthier-Villars, 1889.

A guide to the technique of monumental
and topographical photography.

100. LeGray, Gustave. PHOTOGRAPHIE: TRAITE
NOUVEAU THEORIQUE ET PRATIQUE. Paris:
Lerebours et Secretan, 1854. 387 pp.

Includes instructions for dry and wet
plates, stereoscopy, and photographic
engraving. No illustrations.

"Gustave LeGray...brought photography
on paper to its culmination in the
1850's with the waxed-paper process."
--Helmut and Alison Gernsheim. THE
HISTORY OF PHOTOGRAPHY (see 27).

101. Legros, Adolphe. ENCYCLOPEDIE DE LA
PHOTOGRAPHIE. Paris: Legros, 1851.
333 pp.

Not an encyclopedia but a textbook.
Lacks illustrations.

102. _____ . LE SOLEIL DE LA PHOTO-
GRAPHIE: TRAITE COMPLET. Paris: Legros,
1863. 388 pp.

Not available for annotation.

103. Monckhoven, Desire von. TRAITE GENERAL
     DE PHOTOGRAPHIE. Paris: Gaudin, 1856.
     400 pp.; index.

     A good general textbook, including chap-
     ters on optics and studio equipment.
     The author was half of the extremely
     successful carte-de-visite firm of
     Rabending and von Monckhoven.

104. Nicholls, James. MICROSCOPIC PHOTOG-
     RAPHY. London: Cox, 1860. 30 pp.

     "Mr. Nicholls has here gone fully into
     the subject, minutely describing the
     various instruments that may be used,
     with their respective advantages...it
     will be hailed with pleasure by many
     lovers of photography."
     --THE PHOTOGRAPHIC NEWS, Oct. 12, 1860.

105. Niepce de Saint Victor, Claude F.A.
     RECHERCHES PHOTOGRAPHIQUES. Paris:
     Gaudin, 1855. 140 pp.

     Niepce de Saint Victor was Nicephore
     Niepce's cousin and the inventor of
     the albumen on glass process. Much of
     this work is devoted to the processes
     of heliographic engraving.

106. Robiquet, Edmond. MANUEL THEORIQUE ET
     PRATIQUE DE PHOTOGRAPHIE SUR COLLODION
     ET SUR ALBUMINE. Paris: Labe, 1859.
     309 pp.

     A description of the processes for wet
     and dry collodion, albumen, and carbon,
     followed by extensive essays on the
     chemistry of photography and its opti-
     cal and scientific background.

107. Sella, Venanzio G. PLICO DEL FOTOGRAFO.
     Torino: Paravia, 1856. 415 pp.

     One of the earliest books on photography
     to be published in Italian. Rare.

108. Thornthweite, William H. A GUIDE TO
     PHOTOGRAPHY. London: Horne, Thornthweite
     and Wood, 1845. 48 pp.

     This is the first, rare edition of this
     very popular early manual.

109. Towler, John. THE SILVER SUNBEAM: A
     PRACTICAL AND THEORETICAL TEXT-BOOK
     ON SUN DRAWING AND PHOTOGRAPHIC PRINT-
     ING, COMPREHENDING ALL THE WET AND DRY
     PROCESSES. N.Y.: Ladd, 1864. 351 pp.;
     index.

     One of the most popular handbooks of
     photography ever published (it lasted
     through nine editions). Towler was at
     the time of publication the editor of
     THE DAGUERREIAN JOURNAL, the first
     American photographic periodical.

     Reprinted with an introduction by
     Beaumont Newhall by Morgan & Morgan,
     Hastings-on-Hudson, NY in 1969.

110. Valicourt, E. de. PHOTOGRAPHIE SUR
     METAL, SUR PAPIER ET SUR VERRE. 2v.
     Paris: Roret, 1862. 256, 340 pp.

     A detailed handbook in the Encyclo-
     pedie-Roret series, designed for the
     experienced amateur. Includes numerous
     historical notes and extensive passages
     on theory and technique directly (by
     quotations) or indirectly (by attri-
     bution) from other writers. An earlier
     edition (1861) was in one volume.

111. Vivarez, Henry. UN PRECURSEUR DE LA PHOTO-
     GRAPHIE DANS L'ART DU PORTRAIT A BON
     MARCHE: LE PHYSIONOTRACE. Lille: Lefebvre-
     Ducrocq, 1906. 36 pp.

     A physionotrace was a device used to
     trace a sitter's profile for a silhou-
     ette-- an early attempt at a mechanical
     means of copying reality. This little
     book traces the development of the in-
     strument by its inventor, Gilles-Louis
     Chretien. Reprinted by Arno, N.Y. in
     1979 in THE PREHISTORY OF PHOTOGRAPHY.

112. Vogel, Hermann W. DIE CHEMISCHEN WIR-
     KUNGEN DEN LICHTS UND DIE PHOTOGRAPHIE.
     Leipzig: Brockhaus, 1874. 280 pp.

     Vogel was a chemistry professor who
     conducted early experiments in color
     research (see 148). An English ed. of
     this work was published by Appleton,
     N.Y. in 1875 and reprinted by Arno,
     N.Y. in 1973.

113. _____. HANDBOOK OF THE PRACTICE
     AND ART OF PHOTOGRAPHY. Philadelphia:
     Benerman & Wilson, 1871. 331 pp.

     "...as I look through its rich and
     genial pages, I more than before regret
     that professorial duties prevented my
     meeting the accomplished author during
     his recent visit to our country. To his
     work I have given the place of honor in
     my photographic library, and would
     earnestly recommend it to every photo-
     grapher in America."
       --O.G. Mason, in a letter to PHOTOGRAPHIC
     WORLD, June 1871. Note that Benerman &
     Wilson published PHOTOGRAPHIC WORLD.

114. _____ . LEHRBUCH DER PHOTO-
     GRAPHIE. Berlin: Oppenheim, 1870.
     493 pp.

     A complete summary of scientific theory
     and practice as applied to photography,
     with many illustrations.

ALBUMEN PROCESSES

     see: COLLODION PROCESSES

AMBROTYPES

     see: COLLODION PROCESSES

CALOTYPES

115. Brettell, Richard R. et al. PAPER AND
     LIGHT: THE CALOTYPE IN FRANCE AND
     GREAT BRITAIN, 1839-1870. Boston:
     Godine, 1984. 216 pp.; bibliography,
     index of photographers.

     Three essays by various authors on
     the history and esthetics of the first
     positive/negative paper prints, pro-
     duced in conjunction with an exhibition
     at the Museum of Fine Arts, Houston,
     and the Art Institute of Chicago.
     141 plates.

116. Jammes, Andre and Janis, Eugenia P.
     THE ART OF THE FRENCH CALOTYPE: WITH A
     CRITICAL DICTIONARY OF PHOTOGRAPHERS,
     1845-1870. Princeton: Princeton Univ.
     Press, 1983. 284 pp.; bibliography,
     index.

A history of the calotype process and
its development in France, 69 full-
page plates reproducing French calotypes,
and a dictionary of over 100 French
calotypists, each entry supported by
a brief biographical sketch and printed
references if known.

117. Sutton, Thomas. THE CALOTYPE PROCESS:
A HANDBOOK TO PHOTOGRAPHY ON PAPER.
London: Cundall, 1855. 91 pp.

A straightforward guide to calotype
photography. Marginal glosses provide
easy reference. No illustrations, but
small samples of washed and unwashed
iodized papers are pasted down facing
the title page.

CAMERA HISTORY

118. Auer, Michel. THE ILLUSTRATED HISTORY
OF THE CAMERA FROM 1839 TO THE PRESENT.
Trans. and adapted by D.B. Tubbs.
Boston: New York Graphic Society, 1975.
285 pp.

Approximately half the book is devoted
to 19th century camera technology.
Primarily illustrations, some color.

119. Coe, Brian. CAMERAS: FROM DAGUERREO-
TYPE TO INSTANT PICTURES. N.Y.: Crown,
1978. 232 pp.; index.

Not available for annotation.

120. Gilbert, George. COLLECTING PHOTOGRAPH-
ICA: THE IMAGES AND EQUIPMENT OF THE
FIRST HUNDRED YEARS OF PHOTOGRAPHY.
N.Y.: Hawthorn, 1976. 302 pp.; bibliog-

raphy, index.

An illustrated history of cameras and camera accessories, with instructions on how to identify and collect this kind of photographica and interviews with amateur and professional collectors.

121. Lothrop, Eaton S., Jr. A CENTURY OF CAMERAS FROM THE COLLECTION OF THE INTERNATIONAL MUSEUM OF PHOTOGRAPHY. Dobbs Ferry, NY: Morgan & Morgan, 1973. 150 pp.; index.

Primarily 19th century cameras. Each camera is illustrated (often in several views), with a short history and description for each. Contemporary references are cited at the end of each entry.

## CARBON PROCESSES

122. Despaquis. PHOTOGRAPHIE AU CHARBON. Paris: Leiber, 1866. 72 pp.

The earliest treatise on carbon processes and printing.

123. Monckhoven, Desire von. HISTORIQUE DU PROCEDE AU CHARBON. Gand: Annout-Braekman, 1875. 29 pp.

Recounts in chronological order 17 various carbon printing techniques.

124. _____. TRAITE PRATIQUE DE PHOTOGRAPHIE AU CHARBON. Paris: Masson, 1876. 101 pp.

Monckhoven was a historian of the carbon process (see 123). This volume briefly summarizes the work of the earlier volume and then provides a basic manual to the process.

125. Vidal, Leon. TRAITE PRATIQUE DE PHOTO-GRAPHIE AU CHARBON. Paris: Gauthier-Villars, 1877. 132 pp.

A complete, detailed treatise on carbon printing. Includes numerous illustrations, some original photographs.

126. Wilson, Edward L. THE AMERICAN CARBON MANUAL. N.Y.: Scovill, 1868. 100 pp.

A manual for carbon printing, sandwiched between an essay on the value of the process and a historical review of the process' development. Few illustrations. Reprinted by Arno, N.Y. in 1973.

COLLODION PROCESSES

127. Archer, Frederick S. THE COLLODION PRO-CESS ON GLASS. London: Archer, 1854. 2nd ed. 100 pp.

Archer published the first account of this new process in 1851; this is a manual for its use. Reprinted in THE COLLODION PROCESS AND THE FERROTYPE, published by Arno, N.Y. in 1973.

128. Belloc, Auguste. TRAITE THEORIQUE ET PRATIQUE DE LA PHOTOGRAPHIE SUR COL-LODION. Paris, chez l'auteur, 1854. 208 pp.

A comprehensive and intelligent survey

of the history and methods of photography to date. The emphasis is on collodion work, but Talbot's and other processes are discussed.

129. Brebisson, Alphonse de. TRAITE COMPLET DE PHOTOGRAPHIE SUR COLLODION. Paris: Chevalier, 1855. 134 pp.

Not available for annotation.

130. Burgess, Nathan G. THE AMBROTYPE MANUAL. N.Y.: Burgess, 1856. 184 pp.

Burgess was in Paris with Daguerre in the 1840's. A later edition of this book, including other processes, was published under the title THE PHOTOGRAPH MANUAL by Appleton, N.Y. in 1863, and reprinted by Arno, N.Y. in 1973.

131. Duboscq, J. REGLES PRATIQUES DE LA PHOTOGRAPHIE SUR PLAQUE, PAPIER, ALBUMINE ET COLLODION. Paris: chez l'Auteur, 1853. 46 pp.

Probably the first manual in French to include collodion.

132. Hardwich, Thomas E. A MANUAL OF PHOTOGRAPHIC CHEMISTRY, INCLUDING THE PRACTICE OF THE COLLODION PROCESS. London: Churchill, 1855. 2 ed. 344 pp.

The first edition, which is rare, was published in 1850.

"We have plenty of manuals of directions for the collodion process...but few of them go beyond the technical directions necessary for learning the art of photography; the work before us is of a different and more ambitious character...

it will soon be in the hands of most
practical photographers."
--JOURNAL OF THE PHOTOGRAPHIC SOCIETY,
Vol. 2, 1856.

133. Humphrey, Samuel D. A PRACTICAL MANUAL
OF THE COLLODION PROCESS. N.Y.: Hum-
phrey's Journal, 1857. 3 ed. 215 pp.

According to William Welling (see 72),
this is one of "the first American
photography manuals covering the prac-
tice of the collodion wet-plate process."

134. Neff, Peter and Waldack, Charles.
TREATISE OF PHOTOGRAPHY ON COLLODION.
Cincinnati: Moore, 1857. 124 pp.

Hamilton Smith invented the method of
blackening iron plates to make tin-
types, and Neff received the copyright
for this from him in 1856. This manual
thus includes the probable first report
of the tintype process.

COLLOTYPES

see: GELATIN EMULSION PROCESSES

COLOR PHOTOGRAPHY

135. Calmette, Louis. LUMIERE, COULEUR ET
PHOTOGRAPHIE. Paris: Societe d'Editions
Scientifiques, 1893. 115 pp.

Not available for annotation.

136. Cros, Charles. SOLUTION GENERALE DU
PROBLEME DE LA PHOTOGRAPHIE DES COU-
LEURS. Paris: Gauthier-Villars, 1869.
12 pp.

"Charles Cros independently published
the correct principle of the subtrac-
tive colour method two days after the
granting of a patent to Ducos du Hauron
on 23rd February, 1869."
--Helmut Gernsheim. THE HISTORY OF
PHOTOGRAPHY (see 27). Reprinted in TWO
PIONEERS OF COLOR PHOTOGRAPHY. N.Y.:
Arno, 1979.

137. Ducos du Hauron, Alcide. LA PHOTOGRAPHIE
DES COULEURS ET LES DECOUVERTES DE LOUIS
DUCOS DU HAURON. Paris: Guyot, 1890.
186 pp.

An understandably prejudiced tribute to
Louis Ducos du Hauron by his brother.

138. Ducos du Hauron, Louis. LES COULEURS EN
PHOTOGRAPHIE: SOLUTION DU PROBLEME.
Paris: Marion, 1869. 57 pp.

"Louis Ducos du Hauron made the greatest
contribution to the evolution of colour
photography in the nineteenth century."
--Helmut and Alison Gernsheim. THE
HISTORY OF PHOTOGRAPHY (see 27).
Reprinted in TWO PIONEERS OF COLOR
PHOTOGRAPHY. N.Y.: Arno, 1979.

139. Ducos du Hauron, Alcide & Louis. TRAITE
PRATIQUE DE PHOTOGRAPHIE DES COULEURS.
Paris: Gauthier-Villars, 1878. 108 pp.

Also reprinted in TWO PIONEERS OF COLOR
PHOTOGRAPHY (see above).

140. Dumoulin, Eugene. LES COULEURS REPRO-
DUITES EN PHOTOGRAPHIE: HISTORIQUE,
THEORIE PRATIQUE. Paris: Gauthier-
Villars, 1876. 63 pp.

A recounting of Ducos du Hauron's and

Cros' work, with a simple explanation
of the processes.

141. Drouin, Felix. LA PHOTOGRAPHIE DES
     COULEURS. Paris: Mendel, 1896. 115 pp.

     A basic manual on color processing.
     Features a chapter on chromoscopic
     projection.

142. Gamble, William B. COLOR PHOTOGRAPHY:
     A LIST OF REFERENCES IN THE NEW YORK
     PUBLIC LIBRARY. With an introduction
     by E.J. Wall. N.Y.: New York Public
     Library, 1924. 123 pp.; subject and
     author indexes.

     Contains over 2000 references on every
     aspect of color reproduction, primarily
     found in periodicals. Arranged chrono-
     logically; nearly 400 entries pre-date
     1900.

143. Niewenglowski, Gaston-Henri et Ernault,
     Armand. LES COULEURS ET LA PHOTOGRAPHIE:
     REPRODUCTION PHOTOGRAPHIQUE DIRECTE ET
     INDIRECTE DES COULEURS--HISTORIQUE,
     THEORIE, PRATIQUE. Paris: Societe
     d'Editions Scientifiques, 1895. 368 pp.;
     bibliography.

     Essays on the theories of light and
     color followed by histories and des-
     criptions of the various processes used
     for color photography.

144. Rintoul, A.N. A GUIDE TO PAINTING PHOTO-
     GRAPHIC PORTRAITS IN WATERCOLOURS.
     London: Barnard, 1855. 44 pp.

     Similar to Simons' manual (see 145). In-
     cludes colored diagrams for indicating
     complexion, hair color, etc.

145. Simons, M.P. PLAIN INSTRUCTIONS FOR
     COLOURING PHOTOGRAPHS IN WATER COLOURS
     AND INDIA INK. Philadelphia: Collins,
     1857. 42 pp.

     A brief manual on adapting the palette
     and detailing of miniature painting to
     the hand-coloring of photographs.

146. Simpson, George W. ON THE PRODUCTION
     OF PHOTOGRAPHS IN PIGMENTS, CONTAINING
     HISTORICAL NOTES ON CARBON PRINTING.
     London: Piper, 1867. 103 pp.

     Not available for annotation.

147. Vidal, Leon. PHOTOGRAPHIE DES COULEURS
     ET PROJECTIONS POLYCHROMES. Paris:
     Larousse, 1893. 14 pp.

     Concerned primarily with the prepara-
     tion of colored slides for the chromo-
     scope.

148. Vogel, Hermann W. DIE PHOTOGRAPHIE
     FARBIGER GEGENSTANDE IN DEN RICHTIGEN
     TONVERHALTNISSEN. Berlin: Oppenheim,
     1885. 157 pp.

     Vogel was integral in expanding the
     range of colors which could be repro-
     duced in photography to yellows and
     greens.

149. Wall, Alfred H. A MANUAL OF ARTISTIC
     COLOURING AS APPLIED TO PHOTOGRAPHS.
     London: Piper, 1861. 266 pp.; index.

     A textbook. Includes painting on glass
     or paper, and in watercolors or oils.

DAGUERREOTYPES

150. Bisbee, Albert. THE HISTORY AND PRACTICE
     OF DAGUERREOTYPING. Dayton, OH: Claflin,
     1853. 104 pp.

     A short summary of Daguerre's discoveries
     followed by simple instructions (along
     the lines of a recipe book) for amateur
     photographers. Reprinted by Arno, N.Y.
     in 1973.

151. Buron. DESCRIPTION DE NOUVEAU DAGUERREO-
     TYPES PERFECTIONNES ET PORTRATIFS. Paris:
     Buron, 1841. 47 pp.

     An example of photographic incunabula.
     Not available for annotation.

152. Chevalier, Charles L. MELANGES PHOTO-
     GRAPHIQUES. Paris, chez l'Auteur, 1844.
     127 pp.

     An early daguerreotype manual. Chevalier
     was an optician who provided Niepce with
     his first lenses and cameras.

153. _____. NOUVELLES INSTRUC-
     TIONS SUR L'USAGE DU DAGUERREOTYPE.
     Paris, chez l'Auteur, 1841. 78 pp.
     plus a fold-out plate of instructions.

     One of the earliest manuals of general
     instruction for photography. Includes
     advice on choosing a subject and hand-
     coloring prints.

154. Gaudin, Marc A. et Lerebours, N.P.
     DERNIERS PERFECTIONNEMENTS APPORTES AU
     DAGUERREOTYPES. Paris: Lerebours, 1841.
     77 pp.

     One-page chapters on each aspect of the
     daguerrean process, with a folding plate
     of illustrations in the back. An English

translation by J. Egerton was published
by Longmans in London in 1843.

155. Gouraud, Jean-Baptiste. DESCRIPTION OF
     THE DAGUERREOTYPE PROCESS, OR A SUMMARY
     OF M. GOURAUD'S PUBLIC LECTURES.
     Boston: Dutton and Wentworth, 1840.
     16 pp.

     "The first concrete introduction of
     photography to America...the lecture
     not only provided a set of practical
     instructions but also included a demon-
     stration and an exhibit of finished
     daguerreotypes."
     --Robert Sobieszek and O. Appel. THE
     SPIRIT OF FACT (see 307). Gouraud was
     Daguerre's agent in America.

156. Hill, Levi L. A TREATISE ON DAGUERREO-
     TYPE. Lexington, NY: Holman & Gray,
     1849. 93 pp.

     Hill conducted early experiments--
     some successful--at producing daguerre-
     otypes in natural color. According to
     the Rinharts (see 163), this work "con-
     tained a wealth of easy-to-understand
     information about the art...The publi-
     cation was so instructive that Hill
     used it as a textbook for his Daguerrean
     school, founded in 1850."

157. Humphrey, Samuel D. AMERICAN HAND BOOK
     OF THE DAGUERREOTYPE. N.Y.: Humphrey,
     1853. 144 pp.

     Editor of the DAGUERREAN JOURNAL (1850),
     later known as HUMPHREY'S JOURNAL
     (1851-59), the first photographic
     periodical in America.

158. Kempe, Fritz. DAGUERREOTYPIE IN DEUTSCH-
     LAND: VOM CHARME DER FRUHEN FOTOGRAFIE.
     Seebruck am Chiemsee: Heering, 1979.
     270 pp.; bibliography, name and subject
     indexes.

     A well-detailed and informative history,
     containing over two hundred reproductions.
     The bibliography is largely modern but
     extensive.

159. Mentienne, Adrien. LA DECOUVERTE DE LA
     PHOTOGRAPHY EN 1839. Paris: Dupont, 1892.
     162 pp.

     Includes statements by Niepce and Da-
     guerre, announcements and reports on the
     daguerreotype, a description of the pro-
     cesses, etc. Reprinted by Arno, N.Y. in
     1973.

160. Newhall, Beaumont. THE DAGUERREOTYPE IN
     AMERICA. N.Y.: Duell, Sloan & Pearce,
     1961. 176 pp.; bibliography, index.

     A good narrative history. Eighty three
     full page reproductions. Includes a
     biographical register of American
     daguerreotypists.

161. Queslin, Amedee. LA DAGUERREOTYPE RENDU
     FACILE. Paris, chez l'Auteur, 1843.
     67 p.

     Not available for annotation.

162. Richebourg,  A. NOUVEAU MANUEL COMPLE-
     MENTAIRE POUR L'USAGE PRATIQUE DU
     DAGUERREOTYPE. Paris: Pollet, 1843.
     26 pp.

     Trained by Daguerre, Richebourg penned
     one of photography's rarest incunabula.

163.  Rinhart, Floyd and Marion. THE AMERICAN
      DAGUERREOTYPE. Athens, GA: Univ. of
      Georgia Press, 1981. 446 pp.; dictionary
      of terms, index.

      The Rinharts place a stronger emphasis
      on the technical and business aspects
      of daguerreotypy than Newhall (see 160).
      Included are examinations of the mater-
      ials of photography (apparatus, cases),
      essays on stereoscopic and color daguer-
      reotypes, and a section of thumbnail
      biographies of over 2000 professional
      and amateur daguerreotypists and photo-
      graphic manufacturers and wholesale
      suppliers.

164.  Simons, Montgomery P. PHOTOGRAPHY IN A
      NUTSHELL. Philadelphia: King & Baird,
      1858. 107 pp.

      Simons was one of the great portrait
      daguerreotypists of Philadelphia (see
      145). This work is a typical example
      of a manual for amateurs.

165.  Thierry, J. DAGUERREOTYPIE. Paris:
      Lerebours et Secretan/Lyon: chez
      l'Auteur, 1847. 178 pp.

      The first half of the book is a recount-
      ing of the history of the process, pri-
      marily in the form of the republication
      of original documents. The second half
      of the book contains a description of
      the process. No illustrations.

DRY PLATES

      see: GELATIN EMULSION PROCESS

FERROTYPES

see: TINTYPES

## GELATIN EMULSION PROCESS

166. Chardon, Alfred. PHOTOGRAPHIE PAR
EMULSION SECHE AU BROMURE D'ARGENT
PUR. Paris: Gauthier-Villars, 1877.
70 pp.

An early report on the dry-plate
process.

167. Dillaye, Frederic. LA THEORIE, LA
PRATIQUE, ET L'ART EN PHOTOGRAPHIE
AVEC LE PROCEDE AU GELATINO-BROMURE
D'ARGENT. Paris: Librairie Illustree,
1892. 576 pp.; index.

An historical appreciation and guide to
the dry-plate processes. Includes ex-
planations of theory and technique and
advice for work in various genres. Over
200 illustrations, mostly engravings
and reproductions of photographs.

168. Eder, Joseph M. MODERN DRY PLATES, OR
EMULSION PHOTOGRAPHY. Trans. by H. Baden
Pritchard. London: Piper and Carter,
1881. 138 pp.

Written when the author was only 25.
Eder went on to become one of the first
great photographic historians. (See 17,
18).

## MAGIC LANTERNS AND LANTERN SLIDES

169. Chadwick, William J. THE MAGIC LANTERN
MANUAL. London: Warne, 1878. 138 pp.

A survey of different kinds of lanterns currently in use, followed by brief chapters on producing, mounting, coloring, and viewing slides.

170. Hepworth, Thomas C. THE BOOK OF THE LANTERN. London: Wyman, 1888. 278 pp.

Hepworth was one of the leading advocates of the value of lantern projection. This books is a comprehensive overview of the history and technique of the medium, geared for interested amateurs.

171. _____. EVENING WORK FOR AMATEUR PHOTOGRAPHERS. London: Hazell, 1890. 217 pp.; index.

A guide to the creation and projection of lantern slides. Reprinted by Arno, N.Y. in 1973.

172. Marcy, Lorenzo J. THE SCIOPTICON MANUAL: EXPLAINING MARCY'S NEW MAGIC LANTERN. Philadelphia: Sherman, 1871. 140 pp.

Not available for annotation.

173. Moigno, Francois N. L'ART DES PROJECTIONS. Paris: Gauthier-Villars, 1872. 159 pp.; index.

The Abbe Moigno was a leading scientific educator in his day. This volume is a detailed treatise on the use of lantern projections particularly applied to research and study. Over 100 illustrations.

174. Welford, Walter D. and Sturmey, Henry. THE INDISPENSABLE HANDBOOK TO THE OP-

TICAL LANTERN. London: Iliffe, 1888.
370 pp.; index.

Not available for annotation.

175. Wilson, Edward L. WILSON'S LANTERN
JOURNEYS. Philadelphia: Benerman &
Wilson, 1874 (Vol. 1)/Philadelphia:
Wilson, 1880, 1883 (Vols. 2 & 3).

Each volume prepares an itinerary in
over 100 cities around the world and
offers "guide book" information on
important monuments, sites, etc. which
are located therein. The items in each
itinerary are numbered and apparently
refer to slides available at the time
from the Wilson Company for lectures
or tours.

NEGATIVE PROCESSES

   see: ALBUMEN PROCESSES

        CALOTYPES

        COLLODION PROCESSES

        GELATIN EMULSION PROCESSES

PHOTOGENIC DRAWING

   see: CALOTYPES

PLATINOTYPES

176. Abney, William de W. and Clark, Lyonel.
PLATINOTYPE: ITS PREPARATION AND MANIP-
ULATION. London: Sampson Low, 1895.
174 pp.

Platinum was an expensive and difficult element to use, and there are few useful guides to the process. By the time this and Geymet's manuals were produced (see 177), the process was already out of favor.

177. Geymet, Theophile. TRAITE PRATIQUE DE PLATINOTYPIE SUR EMAIL, SUR PORCELAINE, ET SUR VERRE. Paris: Gauthier-Villars, 1889. 107 pp.

An adaptation of his earlier work on enamel (see 90), with instructions on the platinum process.

178. Pizzighelli, Giuseppe (and) Hubl, Arthur. DIE PLATINOTYPIE: EIN VERFAHREN ZUR RASCHEN HERSTELLUNG HALTBARER COPIEN MIT PLATINSALZEN AUF PHOTOGRAPHISCHEM WEGE. Wien: Photographische Correspondenz, 1882. 86 pp.

Trans. by J. F. Iselin and published in London by Harrison in 1886; reprinted by Arno, N.Y. in 1973: NON-SILVER PRINTING PROCESSES, FOUR SELECTIONS.

"To all who are working the platinotype process we heartily recommend this interesting volume."
--ANTHONY'S PHOTOGRAPHIC REVIEW, Feb. 27, 1896.

POSITIVE PROCESSES

see: CARBON PROCESSES

DAGUERREOTYPES

PLATINOTYPES

SILVER PROCESSES

179. Huberson, G. FORMULAIRE PRATIQUE DE LA
     PHOTOGRAPHIE AUX SELS D'ARGENT. Paris:
     Gauthier-Villars, 1878. 82 pp.

     A manual. Silver printing was a cul-de-
     sac in the history of photography's
     technological development.

180. Robinson, Henry P. & Abney, William.
     THE ART AND PRACTICE OF SILVER PRINT-
     ING. N.Y.: Anthony, 1881. 128 pp.

     Robinson was also responsible for the
     popularity of pictorial (or composite)
     photography, and was a leading photog-
     rapher of his day (see 300-2). This
     is the principal English-language
     manual. Reprinted by Arno, N.Y. in
     1973.

STEREOSCOPIC PHOTOGRAPHY

181. Brewster, David. THE STEREOSCOPE: ITS
     HISTORY, THEORY, AND CONSTRUCTION.
     London: Murray, 1856. 235 pp.

     "The Brewster viewer...simplified the
     enjoyment of the stereographic dimen-
     sional illusion for millions, starting
     in the mid-1850's."
     --George Gilbert. PHOTOGRAPHY: THE
     EARLY YEARS (see 29).

182. Claudet, Antoine F.  DU STEREOSCOPE ET DE
     SES APPLICATIONS A LA PHOTOGRAPHIE. Paris
     Lerebours et Secretan, 1853. 55 pp.

     Claudet improved Brewster's invention
     (see 181) so that the lenses were ad-
     justable.

183. Darrah, William C. STEREO VIEWS: A
     HISTORY OF STEREOGRAPHS IN AMERICA
     AND THEIR COLLECTION. Gettysburg, PA:
     Times and News Pub. Co., 1964. 255 pp.;
     bibliography, index.

     A short world history of stereographs,
     followed by a guide to identifying
     types of stereo views, a detailed his-
     tory of the stereograph in America,
     and a pricing and collecting guide.
     Includes checklists of photographers
     and publishers classified alphabetical-
     ly and by geographic location.

184. LaBlanchere, Henri M. de. MONOGRAPHIE
     DU STEREOSCOPE ET DES EPREUVES STEREO-
     SCOPIQUES. Paris: Aymot, 1861. 330 pp.

     A history of the discovery of the
     stereoscope, the invention and de-
     velopment of stereoscopic technology,
     the theoretical basis of stereo view-
     ing, and a guide to the creation of
     stereo views. Illustrated.

TINTYPES

185. Estabrooke, Edward M. THE FERROTYPE
     AND HOW TO MAKE IT. Cincinnati and
     Louisville: Gatchel & Hyatt, 1872.
     200 pp.; 2 mounted ferrotypes.

     "...Mr. Estabrooke stands at the head
     of the profession in this branch...
     he has brought to his task other qua-
     lities no less essential to success.
     He gives us evidence of ability as a
     ready writer...his every sentence
     indicates the interest he feels in the
     subject, and he evidently conscien-

tiously endeavors to impart to his
readers all the knowledge necessary
to make them good operators."
--ANTHONY'S PHOTOGRAPHIC BULLETIN,
Jan., 1873. Reprinted by Morgan &
Morgan, Hastings-on-Hudson, N.Y., 1972.

186. Trask, Albion K. TRASK'S PRACTICAL
FERROTYPER. Philadelphia: Benerman
& Wilson, 1872. 63 pp.

Contains one original ferrotype as
a frontispiece; no illustrations in the
text. Reprinted in THE COLLODION PRO-
CESS AND THE FERROTYPE, N.Y.: Arno,
1973.

EARLY THEORETICAL TREATISES

PHOTOGRAPHY AS A FINE ART

187. Boord, W.A., ed. SUN ARTISTS. London:
Kegan Paul, 1891.

Eight individually published monographs;
each has 6-8 pp. of text and 4 plates.
Contents: J. Gale by George Davison;
H.P. Robinson by Andrew Pringle; J.B.B.
Wellington by Graham Balfour; Lyddell
Sawyer by F.C. Lambert; Julia Cameron
by P.H. Emerson; B. Gay Wilkinson by
F.C. Lambert; Eveleen Myers by J.A.
Symonds; Frank M. Sutcliffe by Chas. M.
Armfield. Reprinted by Arno, N.Y. in
1973.

188. Otte, Joachim. LANDSCAPE PHOTOGRAPHY.
London: Hardwicke, 1858. 76 pp.

A guide to adapting all photographic
processes to outdoor work, i.e. fold-
ing cameras, field operations, climate
control, etc.

## PICTORIAL PHOTOGRAPHY

189. Adams, W.I. Lincoln. IN NATURE'S IMAGE:
CHAPTERS ON PICTORIAL PHOTOGRAPHY. N.Y.:
Baker & Taylor, 1898. 114 pp.

Essays on the esthetics of art photog-
raphy. Frequently sentimental and
naive in tone, but with many excellent
reproductions.

190. Robinson, Henry P. THE ELEMENTS OF A
PICTORIAL PHOTOGRAPH. Bradford, Eng./
London: Lund, 1896. 167 pp.

(See 180, 300-2). Reprinted by Arno,
N.Y. in 1973.

## MONOGRAPHS ON PHOTOGRAPHERS

### ADAMSON, ROBERT

see: HILL, DAVID OCTAVIUS

### ANNAN, THOMAS, 1829-1887

191. Annan, Thomas. OLD CLOSES & STREETS: A
SERIES OF PHOTOGRAVURES, 1868-1899.
Glasgow: Maclehose, 1900. Not paginated.

"Between 1868 and 1877 Thomas Annan
documented notorious slums for the

Glasgow City Improvement Trust (see
192). Much of his work goes deeper than
the mere recording of a close or alley
to be demolished, for the poverty-
stricken people outside their ram-
shackle wooden houses are a vivid remin-
der to society of its obligation towards
those who work for it."
--Helmut and Alison Gernsheim. THE
HISTORY OF PHOTOGRAPHY (see 27).
Reprinted with item 192 by Dover,
N.Y. in 1977.

192. Annan, Thomas. PHOTOGRAPHS OF OLD CLOSES,
STREETS, & ETC. TAKEN 1868-1877. Glas-
gow: Glasgow City Improvement Trust,
1878/79. Not paginated.

See 191.

ATGET, JEAN EUGENE AUGUSTE, 1856-1927

193. Abbott, Berenice. THE WORLD OF ATGET.
N.Y.: Horizon Press, 1964. 180 plates.

Ms. Abbott acquired most of Atget's
prints and plates upon his death, and
she is principally responsible for
reviving his reputation. This was the
first monograph on his work.

194. Leroy, Jean. ATGET: MAGICIEN DU VIEUX
PARIS EN SON EPOQUE. Joinville le Pont:
Balbo, 1975. Not paginated.

An indifferent selection of reproduc-
tions is compensated by good biographi-
cal research and copies of interesting
original documents.

195. Martinez, Romeo et Pougetoux, Alain.
ATGET: VOYAGES EN VILLE. Presentation
de Pierre Gassmann. Paris: Chene/
Hachette, 1979. 172 pp.

Principally reproductions of views
of streets.

196. Atget, Eugene. EUGENE ATGET. Miller-
ton, NY: Aperture, 1980. (APERTURE
HISTORY OF PHOTOGRAPHY, 14). 95 pp.

An appreciation of Atget, with a small
but well-chosen selection of plates.

197. Szarkowski, John (and) Hambourg,
Maria M. THE WORK OF ATGET. 4v. N.Y.:
Museum of Modern Art, 1981-   . Dis-
trib. by the New York Graphic Society,
Boston. Each volume paginated separate-
ly.

The definitive catalogue raisonne of
Atget's work and the best reproduc-
tions of it available to date. Each
volume is devoted to a particular,
general subject: I. Old France. II.
The art of old Paris. III. The Ancien
Regime (principally the parks and gar-
dens of the 17th & 18th century cha-
teaus). IV. Modern times. The fourth
volume has yet to be published.

BALTZLY, BENJAMIN, 1835-1883

198. Birrell, Andrew. BENJAMIN BALTZLY:
PHOTOGRAPHS & JOURNALS OF AN EXPEDI-
TION THROUGH BRITISH COLUMBIA, 1871.
Toronto: Coach House Press, 1978.
159 pp.

An introductory essay followed by 71
plates and the complete text of Balt-
zly's journal.

BARNARD, GEORGE N., 1819-1902

199. Barnard, George N. PHOTOGRAPHIC VIEWS
     OF SHERMAN'S CAMPAIGN. N.Y.: Bar-
     nard, 1866. 61 plates.

     "When General Sherman left Nashville
     in 1864, Barnard went along as offi-
     cial photographer....his large photo-
     graphs made on this campaign are
     among the rarest and most famous
     of the Civil War period."
     --William Welling. PHOTOGRAPHY IN
     AMERICA (see 72).

BAYARD, HIPPOLYTE, 1801-1887

200. Jammes, Andre. HIPPOLYTE BAYARD: EIN
     VERKANNTER ERFINDER UND MEISTER DER
     PHOTOGRAPHIE. Luzern und Frankfurt a.
     M.: Bucher, 1975. (BIBLIOTHEK DER
     PHOTOGRAPHIE, 8). 95 pp.; bibliog-
     raphy, index.

     "...facts prove Bayard's complete
     independence of Talbot's and Daguerre's
     methods. Bayard deserves a more prom-
     inent position as an independent in-
     ventor of photography than is general-
     ly accorded to him."
     --Helmut and Alison Gernsheim. THE
     HISTORY OF PHOTOGRAPHY (see 27). This
     monograph includes 75 plates.

BEDFORD, FRANCIS, 1816-1894

201. Bedford, Francis. NORTH WALES ILLUS-
     TRATED: A SERIES OF VIEWS. Chester:
     Catherall and Pritchard, 1860.

"Nothing could more forcibly illus-
trate how far the photographer may
also be an artist than these pic-
tures, and the taste, judgement, and
feeling of the beautiful which has
regulated their selection."
 --THE PHOTOGRAPHIC NEWS, Dec. 21,
1860.

202. Fine Arts Gallery, New York State
     University College (Brockport, NY).
     TWO VICTORIAN PHOTOGRAPHERS: FRANCIS
     FRITH, 1822-1898/FRANCIS BEDFORD,
     1816-1894. September 19-October 11,
     1976. Brockport, NY: New York State
     University College, 1976.

     The catalogue of an exhibition; a
     good introduction to Frith and Bed-
     ford's work.

BLANQUART-EVRARD, LOUIS DESIRE, 1802-1872

203. Blanquart-Evrard, Louis D. ON THE
     INTERVENTION OF ART IN PHOTOGRAPHY.
     Trans. by Alfred Harrad, with an
     introduction by Thomas Sutton.
     London: Sampson Low, 1864. 27 pp.

     Blanquart-Evrard was an innovator
     of a variation of the calotype. This
     work is an early example of attempts
     to manipulate the photographic print-
     ing process to create artistic effects.

     Reprinted in THE COLLODION PROCESS
     AND THE FERROTYPE, N.Y.: Arno, 1973.

204. _____. LA PHOTO-
     GRAPHIE: SES ORIGINES, SES PROGRES,
     SES TRANSFORMATIONS. Lille: Danel,
     1870. 66 pp.

A transcription of a lecture given
by Blanquart-Evrard to the Societe
Imperiale des Science, de l'Agri-
culture et des Arts de Lille. The
author quotes extensively from other
documents relating to the history of
photography and its various processes
and intersperses them with his own
comments.

205. _____. TRAITE DE
PHOTOGRAPHIE SUR PAPIER. Paris:
Roret, 1851. 199 pp.

Blanquart-Evrard introduced albumen
print paper; this is an early exam-
ple of a manual for its use.

206. Jammes, Isabelle. BLANQUART-EVRARD ET
LES ORIGINES DE L'EDITION PHOTOGRAPH-
IQUE FRANCAISE. Geneve: Librairie
Droz, 1981. 325 pp.; bibliography,
index.

A scholarly biography followed by a
catalogue raisonne of Blanquart-Evrard's
photographic albums from 1851-1855.
Includes work issued by Blanquart-
Evrard but not necessarily by him:
there are miniature reproductions of
work by Charles Marville, Hippolyte
Bayard, and many others.

BOURNE, SAMUEL, 1834-1912

207. Ollman, Arthur. SAMUEL BOURNE: IMAGES
OF INDIA. Carmel, CA: Friends of
Photography, 1983. (UNTITLED, 33).
22 pp.

"...the leading landscape photog-
rapher in India...Bourne was often
hundreds of miles from civilized
centres for months at a time...ex-
ploring regions in which no white
man had set foot before..."
--Helmut and Alison Gernsheim. THE
HISTORY OF PHOTOGRAPHY (see 27).

BRADY, MATHEW B., 1823-1896

208. Hoobler, Dorothy and Thomas. PHOTO-
GRAPHING HISTORY: THE CAREER OF
MATHEW BRADY. N.Y.: Putnam, 1977.
143 pp.; index.

Not available for annotation.

209. Horan, James D. MATHEW BRADY: HISTO-
RIAN WITH A CAMERA. N.Y.: Crown, 1955.
244 pp.; bibliography, pictorial bib-
liography, index.

The text is not scholarly, but there
are over 450 reproductions of works
by Brady and his assistants.

210. Kunhardt, Dorothy M. and Philip B.,
Jr. MATHEW BRADY AND HIS WORLD.
Alexandria, VA: Time-Life Books,
1977. 304 pp.; index.

The authors are the daughter and grand-
son of Frederick Hill Meserve, whose
collection of Brady material is one
of the most extensive in the world
outside of the Library of Congress.
Mostly reproductions.

211. Meredith, Roy. MATHEW BRADY'S PORTRAIT
OF AN ERA. N.Y.: Norton, 1982. 160 pp.;
index.

Meredith is Brady's principal biographer (see 212,213). This work documents, through photographs by Brady and others, the social life of the day. The text is general, not specifically about Brady.

212. _____. MR. LINCOLN'S CAMERA MAN. N.Y.: Dover, 1974. 2 ed. 368 pp.

Originally published in 1946. It is concerned with the entire scope of Brady's work. Brady's lecture book and its accompanying photographs are reproduced as an appendix.

213. _____. THE WORLD OF MATHEW BRADY: PORTRAITS OF THE CIVIL WAR PERIOD. Los Angeles: Brooke House, 1976. 240 pp.

Approximately 80 full-page reproductions of war scenes and military portraits, each accompanied by several pages of commentary.

BRITT, PETER, 1819-1905

214. Miller, Alan C. PHOTOGRAPHER OF A FRONTIER: THE PHOTOGRAPHS OF PETER BRITT. Eureka, CA: Interface, 1976. 107 pp.

Britt worked in Oregon and the Pacific Northwest. Includes approximately 50 plates.

CAMERON, JULIA MARGARET, 1815-1879

215. Cameron, Julia M. VICTORIAN PHOTO-
     GRAPHS OF FAMOUS MEN AND FAIR WOMEN.
     With introductions by Virginia Woolf
     and Roger Fry. London: Hogarth Press,
     1926. 32 pp. + 34 plates.

     Excellent, full-page reproductions.
     A new edition, expanded and revised
     by Tristam Powell, was published by
     Godine, Boston, in 1973.

216. _____. ALFRED, LORD TEN-
     NYSON AND HIS FRIENDS: A SERIES OF
     25 PORTRAITS. Reminiscences by Anne
     Thackeray Ritchie. Introduction by
     H.H. Hay Cameroon. London: Unwin,
     1893. 16 pp.

     A limited edition of full-page por-
     traits.

217. Ford, Colin. THE CAMERON COLLECTION:
     AN ALBUM OF PHOTOGRAPHS BY JULIA
     MARGARET CAMERON PRESENTED TO SIR
     JOHN HERSCHEL. Workingham, Eng.:
     Van Nostrand Reinhold/in association
     with the National Portrait Gallery,
     London, 1975. 144 pp.; index.

     A brief biographical sketch by Ford
     is followed by a reproduction of the
     original portrait album with notes
     in Mrs. Cameron's hand, and a cata-
     logue raisonne of the album with
     miniature reproductions and more
     complete notes.

218. Ovenden, Graham. A VICTORIAN ALBUM:
     JULIA MARGARET CAMERON AND HER CIRCLE.
     Introductory essay by Lord David Cecil.
     N.Y.: Da Capo, 1975. 252 pp.

119 full-page reproductions, all
portraits. Most are by Cameron, but
a few are by Rejlander, Lewis Carroll,
and others

219. Gernsheim, Helmut. JULIA MARGARET CAMER-
ON, HER LIFE AND PHOTOGRAPHIC WORK.
Millerton, NY: Aperture, 1975. 2 ed.
200 pp.; bibliography, index.

The fullest biography of Cameron to
date but still far from definitive.
Includes approximately 80 full-page
reproductions (all portraits), and
appendices which review (but do not
catalogue) her portrait subjects,
photograph albums, illustrated work,
and manuscripts.

CARROLL, LEWIS

see: DODGSON, CHARLES LUTWIDGE

CHARNAY, DESIRE, 1828-1915

220. Davis, Keith F. DESIRE CHARNAY: EXPEDI-
TIONARY PHOTOGRAPHER. Albuquerque:
Univ. of New Mexico Press, 1981.
212 pp.; bibliography, index.

Charnay documented Mexican primitive
art and architecture. An excellently
researched and composed biographical
study.

CHEVALIER, CHARLES, 1804-1859

221. Chevalier, Arthur. ETUDE SUR LA VIE

ET LES TRAVAUX SCIENTIFIQUES DE
CHARLES CHEVALIER. Paris: Bonaven-
ture et Decessois, 1862. 215 pp.

Not available for annotation.

CURTIS, EDWARD S., 1868-1952

222. Andrews, Ralph W. CURTIS' WESTERN
INDIANS. N.Y.: Bonanza, 1962.
176 pp.; index.

A brief narrative biography, followed
by excerpts from THE NORTH AMERICAN
INDIAN (see 223), classified by
tribe.

223. Curtis, Edward S. THE NORTH AMERICAN
INDIAN. Edited by Frederick W. Hodge;
foreword by Theodore Roosevelt.
20 vols. Cambridge, MA: Harvard
Univ. Press, 1907-30.

"These images stand as a landmark in
the history of artistic photography...
Curtis' images have become the most
sought after of American 'historical'
photographs."
  --Christopher M. Lyman. THE VANISH-
ING RACE (see 225).

"Each volume contains its own appendix
which summarizes the tribes therein...
the volumes of text are accompanied
by twenty corresponding portfolios.
Each volume consists of about 300
pages, and there are 1500 photo-
gravure prints in the text volumes.
Each portfolio consists of 36 or more
copperplate photogravures..."
  --T.C. McLuhan. PORTRAITS FROM NORTH
AMERICAN INDIAN LIFE (see 224).

224. _____. PORTRAITS FROM NORTH
     AMERICAN INDIAN LIFE. Introductions
     by A.D. Coleman and T.C. McLuhan.
     N.Y.: Outerbridge & Lazard, in asso-
     ciation with the American Museum of
     Natural History, 1972; distrib. by
     Dutton, N.Y. 176 pp.

     A selection of full-size reproductions
     from the portfolio volumes of THE NORTH
     AMERICAN INDIAN (see 223).

225. Lyman, Christopher M. THE VANISHING
     RACE AND OTHER ILLUSIONS: PHOTOGRAPHS
     OF INDIANS BY EDWARD S. CURTIS.
     Introduction by Vine Deloria, Jr.
     Washington, D.C.: Smithsonian Insti-
     tution, 1982. 158 pp.; bibliography,
     index.

     Published in conjunction with an ex-
     hibition held at the Smithsonian In-
     stitution and at other locations.
     Over 100 reproductions accompanied
     by an excellent, detailed essay on
     the role of photography in Curtis'
     day and Curtis' life and work.
     Especially valuable are the anno-
     tations to the reproductions which
     explain the various manipulations
     which Curtis undertook to alter the
     content of his photographs and render
     them less truthful.

DAGUERRE, LOUIS JACQUES MANDE, 1787-1851

226. Daguerre, Louis J.M. HISTORIQUE ET
     DESCRIPTION DES PROCEDES DU DAGUERRE-
     OTYPE ET DU DIORAMA. Paris: Giroux,
     1839. 76 pp.

Gernsheim called this the first issue
of the first edition (see 227). It is
not listed in the BIBLIOGRAPHIE DE LA
FRANCE, which lists the edition pub-
lished by Susse Freres in Paris as
registered on September 14, 1839.

227. Gernsheim, Helmut and Alison, L.J.M.
DAGUERRE (1787-1851), THE WORLD'S
FIRST PHOTOGRAPHER. Cleveland: World,
1956. 216 pp.; bibliography, index.

The only life of Daguerre written in
English to date. Well-written and
documented, with 116 illustrations.
It also discusses the history and
influence of the daguerreotype.

228. Potonniee, Georges. DAGUERRE, PEINTRE
ET DECORATEUR. Paris: Montel, 1935.
92 pp.

A study of Daguerre's relatively ob-
scure attempts at painting and stage
design. Reprinted in THE PREHISTORY
OF PHOTOGRAPHY, N.Y.: Arno, 1979.

229. Stenger, Erich. DAGUERRE-SCHRIFTEN.
Berlin: Der Verfasser, 1936. 18 pp.

"An account of the history and editions
of Daguerre's HISTORIQUE...with many
facsimiles."
--Edward Epstean. A CATALOGUE OF THE
EPSTEAN COLLECTION (see 19).

DODGSON, CHARLES LUTWIDGE, 1832-1898

230. Almansi, Guido, ed. LEWIS CARROLL:
PHOTOS AND LETTERS TO HIS CHILD
FRIENDS. Notes by Brassai and Helmut

Gernsheim. Parma, Italy: Franco Maria Ricci, 1975. 213 pp.

One hundred plus full-page, mounted prints, evidently printed from the original negatives, with letters and comments on the facing pages.

231. Gernsheim, Helmut. LEWIS CARROLL, PHOTOGRAPHER. N.Y.: Chanticleer Press, 1950. 126 pp.; bibliography.

A brief and lively discussion of Dodgson's photographic work and social milieu, extensively quoting from Dodgson's journals. 63 reproductions.

A newly revised edition was issued by Dover, N.Y. in 1969.

EASTMAN, GEORGE, 1854-1932

232. Ackerman, Carl W. GEORGE EASTMAN. With an introduction by Edwin R.A. Seligman. Boston: Houghton Mifflin, 1930. 522 pp.; index.

Written two years before Eastman's death, it remains the standard biography on his life and work. What it lacks in critical insight it recoups in attention to detail and proximity to its subject.

EDER, JOSEF MARIA, 1855-1944

233. Dworschak, Fritz (and) Krumpel, Otto. DR. JOSEF MARIA EDER, SEIN LEBEN UND WERK ZUM 100. GEBURTSTAG. Wien; Graphische Lehr- und Versuchanstalt, 1955. 60 pp. + photographic illus.

Two brief essays on Eder, mostly
concerned with his scientific work.

EMERSON, PETER HENRY, 1856-1936

234. Emerson, Peter H. LIFE AND LANDSCAPE
     ON THE NORFOLK BROADS. London: Sampson
     Low, 1886. 81 pp.

     Published in a limited edition. Con-
     tains 40 original photographs with
     text by Emerson and T.F. Goodall.

235. _____. NATURALISTIC
     PHOTOGRAPHY FOR STUDENTS OF THE
     ART. London: Sampson Low, 1889.
     307 pp.; bibliography, index.

     "No book in the history of photog-
     raphy--or perhaps in the history
     of art--has ever caused such vit-
     riolic abuse or such ecstatic
     praise."
      --Nancy Newhall. P.H. EMERSON (see
     237).

     "We have read every line of this book
     from beginning to end and thereby de-
     rived much pleasure, some useful in-
     formation, and a great deal of amuse-
     ment...a remarkable book, and well
     deserves the attention of all who
     wish to see photography elevated to
     its true position."
      -- THE PHOTO-BEACON, Vol. I, No. 5,
     1889.

236. Middleton, C.S. THE BROADLAND PHOTOG-
     RAPHERS: THE PHOTOGRAPHS OF J. PAYNE
     JENNINGS, P.H. EMERSON, AND GEORGE

CHRISTOPHER DAVIES. Norwich: Wensum
Books, 1978. Unpaginated; bibliography
on fly-leaf.

A short but very informative monograph
on Emerson and his circle and their
work. At least three dozen reproduc-
tions, accompanied by captions general-
ly taken from the photographer's own
published work.

237. Newhall, Nancy. P.H. EMERSON: THE
FIGHT FOR PHOTOGRAPHY AS A FINE ART.
Millerton, NY: Aperture, 1975.
266 pp.; bibliography.

A major, scholarly biography, followed
by over 100 reproductions accompanied
by excerpts from Emerson's writings.

238. Turner, Peter and Wood, Richard.
P.H. EMERSON, PHOTOGRAPHER OF NOR-
FOLK. London: Fraser, 1974. 108 pp.;
bibliography. (GORDON FRASER PHOTO-
GRAPHIC MONOGRAPHS, 2).

A brief essay on Emerson's philos-
ophy and techniques. Sixty-four
full-page plates are followed by
miniature reproductions of the same
plates with extensive notes excerpted
from original sources.

FENTON, ROGER, 1819-1869

239. Gernsheim, Helmut and Alison. ROGER
FENTON, PHOTOGRAPHER OF THE CRIMEAN
WAR: HIS PHOTOGRAPHS AND HIS LETTERS
FROM THE CRIMEA. With an essay on his
life and work. London: Secker & War-
burg, 1954. 106 pp.

A brief biographical essay, followed by 85 reproductions--primarily by Fenton, with a half-dozen others by James Robertson--and the slightly edited texts of Fenton's letters to his family and sponsor, William Agnew, from the Crimea. Reprinted by Arno, N.Y. in 1973.

240. Hannavy, John. ROGER FENTON OF CRIMBLE HALL. London: Fraser, 1975. 184 pp.; index. (GORDON FRASER PHOTOGRAPHIC MONOGRAPHS, 3).

A full biography, distinguished by its attention to Fenton's work outside the Crimea. Includes 64 full-page plates, followed by miniature reproductions of the same plates accompanied by extensive notes by the author.

FITZGIBBON, JOHN H., 1816(?)-1882

241. Fitzgibbon, John H. THE NEW PRACTICAL PHOTOGRAPHIC ALMANAC FOR 1879. St. Louis: Maynard & Telford, 1879. 131 pp.

"...probably the most widely travelled and the most popular among the pioneer daguerreotypists."
--Rinhart, Floyd and Marion. THE AMERICAN DAGUERREOTYPE (see 163).

FRITH, FRANCIS, 1822-1898

242. Frith, Francis. CAIRO, SINAI, JERU-SALEM, AND THE PYRAMIDS OF EGYPT: A SERIES OF SIXTY PHOTOGRAPHIC VIEWS.

With descriptions by Mrs. Poole and Reginald Stuart Poole. London: Virtue (1860/1).

See 244.

243. _____. EGYPT, NUBIA, AND ETHIOPIA. London: Smith, Elder, 1862.

Includes 100 pairs of stereographic prints.

244. _____. EGYPT, SINAI, AND JERUSALEM: A SERIES OF TWENTY PHOTO-GRAPHIC VIEWS. With descriptions by Mrs. Poole and Reginald Stuart Poole. London: Mackenzie (1860).

"Francis Frith was...probably the largest publisher of Continental and English views. His fame nowadays rests chiefly on the many publications which ensued from his three tours to Egypt, Nubia, Palestine, and Syria...The finest of these books, EGYPT, SINAI, AND PALESTINE (sic), with text by Mr. and Mrs. Reginald Stuart Poole (ca. 1860) is probably the largest photographically illustrated book ever published: the text pages measure 21" X 29", the photographs being 20" X 16"."
--Helmut and Alison Gernsheim. THE HISTORY OF PHOTOGRAPHY (see 27).

245. Jay, Bill. VICTORIAN CAMERAMAN: FRAN-CIS FRITH'S VIEWS OF RURAL ENGLAND, 1850-1898. Newton Abbot: David & Charles, 1973. 112 pp.; index.

A brief but informative biography of Frith, followed by approximately 50 pages of captioned reproductions.

246. White, Jon E., ed. EGYPT AND THE
     HOLY LAND IN HISTORIC PHOTOGRAPHS:
     77 VIEWS BY FRANCIS FRITH, Intro-
     duction by Julia Van Haaften. N.Y.:
     Dover, 1980. 77 plates + bibliography.

     A well-chosen and well-produced selec-
     tion of Frith's Mideastern work, with
     a scholarly introduction by Ms. Van
     Haaften and good notes to the plates
     by Mr. White.

GARDNER, ALEXANDER, 1821-1882

247. Gardner, Alexander. GARDNER'S PHOTO-
     GRAPHIC SKETCH BOOKS OF THE WAR. 2
     vols. Washington, D.C.: Philip &
     Solomons, 1866. Unpaginated.

     "Gardner's two-volume PHOTOGRAPHIC
     SKETCH BOOK OF THE WAR is considered
     the equal of any work executed during
     the Civil War by Brady or others."
     --William Welling. PHOTOGRAPHY IN
     AMERICA (see 72).

     Reprinted in one volume by Dover,
     N.Y. in 1969. Here the plates are
     numbered; there are 100 of them.

HAWES, JOSIAH JOHNSON

     see: SOUTHWORTH, ALBERT SANDS

HAYNES, F. JAY, 1853-1921

248. Montana Historical Society. F. JAY
     HAYNES, PHOTOGRAPHER. (Helena, MT):
     Montana Historical Society Press,

1981. 192 pp.

151 plates, with a reference list
including subject, date, size, and
the Haynes Collection number assigned
by the Montana Historical Society.

249. Tilden, Freeman. FOLLOWING THE FRON-
TIER WITH F. JAY HAYNES, PIONEER
PHOTOGRAPHER OF THE OLD WEST. N.Y.:
Knopf, 1964. 406 pp.; indexes.

A good biography. The unnumbered re-
productions are plentiful, and a
subject index to them is provided.

HILL, DAVID OCTAVIUS, 1802-1870
ADAMSON, ROBERT, 1821-1848

250. Bruce, David. SUN PICTURES: THE HILL-
ADAMSON CALOTYPES. Greenwich, CT:
New York Graphic Society, 1973.
247 pp.; bibliography, index.

A 25-page essay on Hill and Adamson,
with the rest of the book devoted to
a selection of annotated reproduc-
tions.

251. Elliott, Andrew. CALOTYPES BY D.O. HILL
AND R. ADAMSON ILLUSTRATING AN EARLY
STAGE IN THE DEVELOPMENT OF PHOTOGRAPHY.
Edinburgh: privately printed, 1928.
106 pp. + 47 plates.

A rare, early, and limited edition of
Hill and Adamson's work. Forty seven
portraits, each accompanied by a brief
biographical sketch. Elliott owned
(and presumably printed from) hundreds
of original negatives, and his collec-
tion was eventually sold to the Nation-
al Portrait Gallery (see 254).

252. Ford, Colin, ed. AN EARLY VICTORIAN
     ALBUM: THE HILL/ADAMSON COLLECTION.
     With a commentary by Roy Strong.
     London: Cape, 1974. 350 pp.; index.

     Essays on Hill (primarily) and Adamson
     by Ford and Strong. The reproductions
     are selected from three National Por-
     trait Gallery albums (see 254) and
     classified by their album numbers.

253. Schwarz, Heinrich. DAVID OCTAVIUS HILL,
     MASTER OF PHOTOGRAPHY. Trans. by Helene
     E. Fraenkel. N.Y.: Viking, 1931. 67 pp.

     A good, short biography, augmented by
     eighty annotated reproductions.

254. Stevenson, Sara. DAVID OCTAVIUS HILL
     AND ROBERT ADAMSON: CATALOGUE OF THEIR
     CALOTYPES TAKEN BETWEEN 1843 AND 1847
     IN THE COLLECTION OF THE SCOTTISH
     NATIONAL PORTRAIT GALLERY. Edinburgh:
     National Galleries of Scotland, 1981.
     220 pp.

     A catalogue raisonne of the National
     Portrait Gallery collections, clas-
     sified by genre--i.e. portraits,
     groups, views, etc. The introductory
     essay is very informative.

HILLERS, JOHN K., 1843-1925

255. Hillers, John K. PHOTOGRAPHED ALL THE
     BEST SCENERY: JACK HILLER'S DIARY OF
     THE POWELL EXPEDITIONS, 1871-1875. Ed.
     by Don D. Fowler. Salt Lake City: Univ.
     of Utah Press, 1972. 225 pp.

John Wesley Powell lead several sur-
veys of the Grand Canyon in the ear-
ly 1870's. John K. Hillers and E. O.
Beamon (see 360) provided a rich
legacy of documentation for these
various expeditions. This book is
one of the few detailed textual re-
ports on their work. (See also 257).

256. Morgan, Lewis H. HOUSES AND HOUSE-
LIFE OF THE AMERICAN ABORIGINES.
Washington, D.C.: Government Print-
ing Office, 1881. 281 pp. (CON-
TRIBUTIONS TO NORTH AMERICAN
ETHNOLOGY, 4).

Contains photographs by Hillers.

257. Steward, Julian H. NOTES ON HILLER'S
PHOTOGRAPHS OF THE PALUTE AND UTE
INDIANS TAKEN ON THE POWELL EXPEDI-
TION OF 1873. Washington, D.C.:
Smithsonian Institution, 1939.
31 plates.

See 255.

JACKSON, WILLIAM HENRY, 1843-1942

258. Forsee, Aylesa. WILLIAM HENRY JACKSON,
PIONEER PHOTOGRAPHER OF THE WEST.
Illustrated with drawings by Douglas
Gorsline, and with photographs by
William Henry Jackson. N.Y.: Viking,
1964. 205 pp.

Written for a younger audience, with
a strong narrative and invented dia-
log. 23 reproductions.

259. Jackson, Clarence S. PICTURE MAKER OF
     THE OLD WEST: WILLIAM H. JACKSON. N.Y.:
     Scribner, 1947. 308 pp.; index.

     A biography by Jackson's son. Recounts
     much of the same material as TIME EX-
     POSURE (see 262) and contains in-
     numerable reproductions of Jackson's
     work with his son's commentary.
     Reprinted by Scribner in 1971.

260. Jackson, William H. THE CANYONS OF
     COLORADO FROM PHOTOGRAPHS. Denver:
     Thayer, 1900. 1 continuous leaf.

     17 labeled plates. No text or
     commentary, and probably intended
     as a souvenir.

261. _____ and Driggs,
     Howard R. THE PIONEER PHOTOGRAPHER:
     ROCKY MOUNTAIN ADVENTURES WITH A
     CAMERA. Yonkers-on-Hudson: World,
     1929. 314 pp.; index.

     Provides the information on specifics
     of technique which are lacking from
     TIME EXPOSURE (see 262).

262. _____. TIME EXPOSURE:
     THE AUTOBIOGRAPHY OF WILLIAM HENRY
     JACKSON. N.Y.: Putnam, 1940.

     Jackson published these memoirs when
     he was ninety-seven. It remains the
     richest source of biographical mater-
     ial for studies of his life, but
     sheds little light on his work.
     Reprinted by Cooper Square Publishers,
     N.Y. in 1970.

263. Miller, Helen M. LENS ON THE WEST: THE
     STORY OF WILLIAM HENRY JACKSON. Garden

City, NY: Doubleday, 1966.

Not available for annotation

264. Jones, William C. and Elizabeth B.
WILLIAM HENRY JACKSON'S COLORADO.
Foreword by Marshall Sprague. Boul-
der, CO: Pruett, 1975. 172 pp.

Almost entirely full-page repro-
ductions of Jackson's views of
Colorado landscapes and cities.

265. Newhall, Beaumont & Edkins, Diana
E. WILLIAM H. JACKSON. With a
critical essay by William L.
Broeker. Ft. Worth, TX: Amon Carter
Museum of Western Art/Dobbs Ferry,
NY: Morgan & Morgan, 1974. 158 pp.;
bibliography.

Mostly reproductions, but the prints
are good and the chronology and bib-
liography are useful.

266. The White City Art Co. THE WHITE CITY
(AS IT WAS). Chicago: White City Art
Co., 1894. 80 plates.

Photographs by Jackson of the World's
Columbian Exposition, held in Chicago
in 1893. Originally published in 20
parts.

JENNINGS, JOHN PAYNE, 1849-1923

see also: EMERSON, PETER HENRY

267. Jennings, Payne. SUN PICTURES OF THE
NORFOLK BROADS. With letterpress des-
cription by Ernest R. Suffling.
Ashtead, Eng.: Jennings, 1897.
100 plates.

Jennings was commissioned by the Great
Eastern Railway Company to document the
Broads. An earlier edition of this work
was published by Jarrolds without com-
mentary in 1890.

MARTIN, PAUL, 1864-1944

268. Flukinger, Roy et al. PAUL MARTIN,
VICTORIAN PHOTOGRAPHER. Austin and
London: Univ. of Texas Press, 1977.
221 pp.; bibliography, index.

A long biographical essay on Martin,
a shorter essay on London life in the
1890's, and nearly 100 plates by Mar-
tin.

269. Jay, Bill. VICTORIAN CANDID CAMERA:
PAUL MARTIN, 1864-1944. Introduc-
tion by Sir Cecil Beaton. Newton
Abbot: David & Charles, 1973. 112 pp.

A brief biographical essay followed
by approximately 60 reproductions.

270. Martin, Paul. VICTORIAN SNAPSHOTS.
With an introduction by Charles
Harvard. London: Country Life, 1939.
52 pp. of text; 72 reproductions.

The first half of the book contains
Martin's reminiscences; the second
half includes his general comments
on the subjects of his photographs
and captions for those specifically
reproduced here. Reprinted by Arno,
N.Y. in 1973.

MATSURA, FRANK, d. 1913

271. Roe, Joann. FRANK MATSURA, A FRONTIER

PHOTOGRAPHER. Seattle: Madrona, 1981.
144 pp.

Primarily plates. A good essay, but
no index or catalogue. Matsura was
born in Japan and worked in the Paci-
fic Northwest.

MUYBRIDGE, EADWEARD JAMES, 1830-1904

272. Haas, Robert B. MUYBRIDGE: MAN IN MO-
TION. Berkeley: Univ. of California
Press, 1976. 207 pp.; index.

A full biography, concerned with every
aspect of Muybridge's life and work,
with over 150 reproductions and illus-
trations.

273. Hendricks, Gordon. EADWEARD MUYBRIDGE:
THE FATHER OF THE MOTION PICTURE.
N.Y.: Grossman, 1975. 271 pp.; bib-
liography, index.

A less detailed biography than Haas's
(see 272), but with a greater emphasis
on Muybridge's experiments with re-
cording motion. Nearly 200 reproduc-
tions and illustrations.

274. MacDonnell, Kevin. EADWEARD MUYBRIDGE,
THE MAN WHO INVENTED THE MOVING PIC-
TURE. Boston: Little, Brown, 1972.
158 pp.; bibliography.

A 32-page biographical essay, followed
by unnumbered, captioned reproductions
taken from every stage of Muybridge's
work.

275. Marks, W.D. et al. ANIMAL LOCOMOTION:
THE MUYBRIDGE WORK AT THE UNIVERSITY

OF PENNSYLVANIA--THE METHOD AND THE
RESULT. Philadelphia: Lippincott,
1888. 136 pp.; index.

Three scientific studies of Muybridge's
work. The illustrations are line draw-
ings copied from photographs. Reprinted
by Arno, N.Y. in 1973.

276. Muybridge, Eadweard. ANIMAL LOCOMOTION.
Philadelphia: Univ. of Pennsylvania,
1887. 781 plates.

"...(the plates were) printed on heavy
linen paper sheets 19 X 24 inches in
size, each plate comprising from 10
to 48 separate pictures. The work was
issued in several forms. All 781
plates could be purchased for $500,
encased in leather portfolios, or for
an additional $50 bound into 11 vol-
umes. For $100, a purchaser could ob-
tain a selection of 100 plates, un-
bound...plus such additional plates
as he wished for $1 each."
--Lewis S. Brown, in ANIMALS IN
MOTION, N.Y.: Dover, 1957.

The entire set of plates (of which
ANIMALS IN MOTION was a selection)
was reprinted in 3 vols. by Dover
in 1979.

277. Wurttembergischer Kunstverein Stutt-
gart. EADWEARD MUYBRIDGE. (October
21-November 28, 1976). Stuttgart:
Wurttembergischer Kunstverein, 1976.
128 pp.; bibliography.

An excellent exhibition catalogue:
the reproductions and illustrations--
of Muybridge's work and of those who
studied him--help to delineate his

influence, and a selection of docu-
ments in the original English appended
to the catalogue includes writings
by Muybridge, letters, patents, com-
ments, and contemporary reviews.

NADAR

see: TOURNACHON, GASPARD FELIX

NEGRE, CHARLES, 1820-1880

278. Borcoman, James. CHARLES NEGRE, 1820-
1880. Ottawa: National Gallery of
Canada, 1976. 262 pp.; bibliography,
index.

A good, brief biographical essay
followed by 203 full-page repro-
ductions. Parallel texts in French
and English.

279. Jammes, Andre. CHARLES NEGRE, PHOTO-
GRAPHE, 1820-1880. Preface de Jean
Adhemar. Paris: Jammes, 1963. 40 pp.

An appreciation of Negre by Jammes,
interspersed with beautifully pro-
duced, mounted plates, many taken
from the original negatives.

280. Luynes, Honore T. VOYAGE D'EXPLORA-
TION A LA MER MORTE A PETRA ET SUR
LA RIVE GAUCHE DU JOURDAIN. Paris:
Bertrand, 1874. 2 vols. + atlas.

The atlas includes 64 photogravures
by Negre of original photographs
taken primarily by Louis Vignes.
The prints are of extraordinary
clarity and detail.

281. Musee Reattu (Arles).CHARLES NEGRE, PHOTOGRAPHE, 1820-1880. 5 juillet- 17 aout, 1980. Paris: Editions des Musees Nationaux, 1980. 380 pp.; bibliography.

A survey of Negre's work in genre, views, portraits, and landmark photography. Over 150 small reproductions. Appendices include some of Negre's letters and itineraries.

NIEPCE, JOSEPH NICEPHORE, 1765- 1833

282. Fouque, Victor. LA VERITE SUR L'INVENTION DE LA PHOTOGRAPHIE: NICEPHORE NIEPCE; SA VIE, SES ESSAIS, SES TRAVAUX, D'APRES SA CORRESPONDANCE ET AUTRES DOCUMENTS INEDITS. Paris: Librairie des Auteurs et de l'Academie des Bibliophiles, 1867. 282 pp.

Transcriptions of original letters and documents and lively investigative reporting towards proof that Niepce and not Daguerre is the true inventor of photography.

Trans. by Edward Epstean and published by Tennant & Ward, N.Y. in 1935. Reprinted by Arno, N.Y. in 1973.

283. Niepce, Isadore. HISTORIQUE DE LA DECOUVERTE IMPROPREMENT NOMMEE DAGUERREOTYPE, PRECEDE D'UNE NOTICE SUR SON VERITABLE INVENTEUR, JOSEPH NICEPHORE NIEPCE. Paris: Astier, 1841. 72 pp.

Isadore Niepce was Nicephore's son. According to Gernsheim (see 27),

Niepce published this brochure to correct, in his opinion, the inaccurate attribution of the daguerreotype solely to Daguerre. Reprinted in THE PRE-HISTORY OF PHOTOGRAPHY, N.Y.: Arno, 1979.

284. Niepce, Joseph N. CORRESPONDANCES, 1825-1829. Avec une nomenclature des sources manuscrites par Pierre G. Harmant. Rouen: Pavillion de la Photographie, 1974. 191 pp.

Letter-for-letter transcriptions of Niepce's correspondence, primarily with Daguerre. There are several pages of illustrative material.

285. _____. LETTRES, 1816-1817: CORRESPONDANCE CONSERVEE A CHALON-SUR-SAONE. Rouen: Pavillion de la Photographie, 1973. 190 pp.

Similar in format to item 284, but wholly addressed to his brother, Claude (1763-1828).

286. Societe Francaise de Photographie et de Cinematographie (Paris). COMMEMO-RATION DU CENTENAIRE DE LA MORT DE JOSEPH NICEPHORE NIEPCE, INVENTEUR DE LA PHOTOGRAPHIE. Paris: Societe Francaise (etc.), 1933. 78 pp.

Events held in Chalon-sur-Saone in June, 1933. Includes transcriptions of the speeches given in Niepce's honor, examples of Niepce's work, and photographs of the ceremonies.

NOTMAN, WILLIAM, 1826-1891

287. Harper, J. Russell and Triggs, Stanley,
     eds. PORTRAIT OF A PERIOD: A COLLECTION
     OF NOTMAN PHOTOGRAPHS, 1856 to 1915.
     With an introduction by Edgar Andrew
     Collard. Montreal: McGill Univ. Press,
     1967. 174 plates.

     Mostly plates, the majority of which
     were printed from the original nega-
     tives. Includes work produced by the
     Notman firm after the photographer's
     death.

O'SULLIVAN, TIMOTHY, 1840-1882

288. Dingus, Rick. THE PHOTOGRAPHIC ARTI-
     FACTS OF TIMOTHY O'SULLIVAN. Albuquer-
     que: Univ. of New Mexico Press, 1982.
     158 pp.; bibliography, index.

     A biography of O'Sullivan with a special
     emphasis on the esthetics of O'Sullivan's
     framing and selection techniques. In-
     cludes 66 figures, which are small-
     scale reproductions primarily of O'Sul-
     livan's work, and 64 full-page plates.
     Some of these plates compare O'Sul-
     livan views with those taken by the
     author at the same site; the remainder
     are all by O'Sullivan.

289. Horan, James D. TIMOTHY O'SULLIVAN,
     AMERICA'S FORGOTTEN PHOTOGRAPHER.
     Garden City, NY: Doubleday, 1966.
     334 pp.; bibliography, index.

     The first book to consider O'Sullivan
     separately from Brady. Nearly 400 re-
     productions. The text quotes frequent-
     ly from original sources.

290. Newhall, Beaumont and Nancy, T.H.
     O'SULLIVAN, PHOTOGRAPHER. With an
     appreciation by Ansel Adams. Roches-
     ter, NY: George Eastman House/Ft.
     Worth, TX: Amon Carter Museum of
     Western Art, 1966. Unpaginated.

     Five pages of introductory material
     and 40 prints. Includes a chronology
     and a brief biography.

291. Snyder, Joel. AMERICAN FRONTIERS: THE
     PHOTOGRAPHS OF TIMOTHY H. O'SULLIVAN,
     1867-1874. Millerton, NY: Aperture,
     1981; distrib. by Harper & Row, N.Y.
     118 pp.; bibliography.

     Published in conjunction with an ex-
     hibition at the Alfred Stieglitz Cen-
     ter at the Philadelphia Museum of Art,
     October 3, 1981-January 3, 1982. An
     essay on O'Sullivan is accompanied
     by partial and full-page plates which
     are excellently reproduced.

292. Wheeler, George M. PHOTOGRAPHS SHOWING
     LANDSCAPES, GEOLOGICAL AND OTHER
     FEATURES, OF PORTIONS OF THE WESTERN
     TERRITORY OF THE UNITED STATES.
     Washington, D.C.: War Department/
     Corps of Engineers, 1875. 50 plates.

     Originally produced as a supplement
     to Wheeler's seven volume survey re-
     port in three suites-- the first and
     last being by O'Sullivan; the remain-
     der by William Bell. Reprinted by
     Dover, N.Y. in 1983.

REJLANDER, OSCAR GUSTAVE, 1813-1875

293. Bunnell, Peter C., ed. THE PHOTOGRAPHY
     OF O.G. REJLANDER: TWO SELECTIONS. N.Y.:
     Arno, 1979. Unpaginated.

     A reprint of two periodical pieces:
     Rejlander's ON PHOTOGRAPHIC COMPOSITION
     (1858) and A.H. Wall's REJLANDER'S
     PHOTOGRAPHIC STUDIES (1886/7).

294. Jones, Edgar Y. THE FATHER OF ART PHOTOG-
     RAPHY: O.G. REJLANDER, 1813-1875. New-
     ton Abbot: David & Charles, 1973. 112 pp.

     A brief but adequate biography fol-
     lowed by approximately 60 captioned
     reproductions.

RIIS, JACOB A., 1849-1914

295. Alland, Alexander, Sr. JACOB A. RIIS,
     PHOTOGRAPHER & CITIZEN. With a pre-
     face by Ansel Adams. Millerton, NY:
     Aperture, 1974. 220 pp.; bibliography,
     index.

     A brief biographical essay followed
     by 162 full-page prints.

296. Doherty, Robert J., ed. THE COMPLETE
     PHOTOGRAPHIC WORK OF JACOB A. RIIS.
     N.Y.: Macmillan, 1981. 38 pp. +
     8 microfiches containing 632 plates.

     "(This book) will contain all the
     variations of individual pictures
     in a collection as well as any vari-
     ations in the descriptive matter re-
     lating to each picture...there will
     be no attempt at selective editing.
     Thus, every picture in the Museum of
     the City of New York's Riis Collection
     is included in this publication."
     --from the preface.

297. Hassner, Rune. JACOB A. RIIS, REPORTER
     MED KAMERA I NEW YORKS SLUM. Stockholm:
     Norstedt, 1970. 189 pp.; bibliography.

     A well-documented history of Riis's work.
     The bibliography is extensive and an-
     notated, and includes the titles and
     dates of publication for all of Riis's
     newspaper work as well as notes on all
     of the books in which his work served
     as illustration.

298. Riis, Jacob A. HOW THE OTHER HALF LIVES:
     STUDIES AMONG THE TENEMENTS OF NEW YORK.
     N.Y.: Scribner, 1890.

     "HOW THE OTHER HALF LIVES...quickly be-
     came a landmark in the annals of Ameri-
     can social reform..."
     --Charles A. Madison, in his preface
     to the reprint of the 1901 edition of
     this work, published by Dover, N.Y. in
     1971.

299. Ware, Louise. JACOB A. RIIS, POLICE
     REPORTER, REFORMER, USEFUL CITIZEN.
     Introduction by Allan Nevins. N.Y.:
     Appleton-Century, 1938. 335 pp.;
     bibliography, index.

     A full biography, discussing Riis's
     activities as a journalist, social
     critic, and photographer. Reprinted
     by Kraus, Millwood, NY, in 1975.

ROBINSON, HENRY PEACH, 1830-1901

300. Robinson, Henry P. PICTORIAL EFFECT IN
     PHOTOGRAPHY, BEING HINTS ON COMPOSITION
     AND CHIAROSCURO FOR PHOTOGRAPHERS. Lon-
     don: Piper & Carter, 1869. 199 pp.

"Mr. Robinson has made for himself
a high position both as an artist and
author, and in this book he freely
gives us the lines on which his suc-
cess has been wrought out. Although
an artist in the true sense of the
word, he does not affect to discard
the acknowledged canons of art, but
employs them freely as the skeleton,
putting his own individuality as the
soul of his work."
--THE PHOTO-BEACON, Vol. I, No. 5,
1889.

Reprinted with an introduction by
Robert S. Sobieszek by Helios, Paw-
let, VT, in 1971.

301.  _____. PICTURE-MAKING
BY PHOTOGRAPHY. N.Y.: Scovill, 1884.
128 pp.

"...every line is agreeable reading,
and every page is full of valuable
teachings, the result of life-long
study by an artist who has won for
himself a name in painting and etch-
ing no less than in photography...
Mr. Robinson's teachings will be none
the less valuable because they are
personal..."
--THE PHOTOGRAPHIC NEWS, April 25, 1884.

Reprinted by Arno, N.Y. in 1973.

302.  _____. LETTERS ON LAND-
SCAPE PHOTOGRAPHY. N.Y.: Scovill,
1888. 94 pp.

A collection of Robinson's pieces on
the theory and esthetics of outdoor
photography, originally published in

THE PHOTOGRAPHIC TIMES in 1887.
Reprinted by Arno, N.Y. in 1973.

RUSSELL, ANDREW JOSEPH, 1830-1902

303. Russell, Andrew J. RUSSELL'S CIVIL WAR
     PHOTOGRAPHS: 116 HISTORIC PRINTS. With
     a preface by Joe Buberger and Matthew
     Isenberg. N.Y.: Dover, 1982. 116 plates.
     The plates are reproduced from original
     prints.

SARONY, NAPOLEON, 1821-1896

304. Bassham, Ben L. THE THEATRICAL PHOTO-
     GRAPHS OF NAPOLEON SARONY. Kent, OH:
     Kent State Univ. Press, 1978. 122 pp.;
     bibliography.

     A brief essay on Sarony, followed by
     approximately 80 reproductions of his
     portrait carte-de-visites. Each por-
     trait is faced with a biographical
     sketch of the subject.

305. Sarony, Napoleon. SARONY'S LIVING
     PICTURES. N.Y.: Chasmar (1894).

     Eight volumes bound together as one,
     some alternatively titled SARONY'S
     SKETCH BOOK. Illustrations taken
     from hand-painted photographs.

     "If there is a unifying theme, it is
     Sarony's determined attempt to show
     that photography can be elevated to
     an art form through the imitation of
     paintings."
     --Ben L. Bassham. THE THEATRICAL PHOTO-
     GRAPHS OF NAPOLEON SARONY (see 304).

SOUTHWORTH, ALBERT SANDS, 1811-1894
HAWES, JOSIAH JOHNSON, d. 1901

306. Homer, Rachel J. THE LEGACY OF JOSIAH
JOHNSON HAWES: 19TH CENTURY PHOTOGRAPHS
OF BOSTON. Barre, MA: Barre Publishers,
1972. 131 pp.; bibliography.

A selection of Hawes's work, mostly taken
after Southworth's departure from the
partnership in 1861. Over 100 plates,
printed from glass negatives and origi-
nal prints.

307. Sobieszek, Robert A. and Appel, Odette
M. THE SPIRIT OF FACT: THE DAGUERREOTYPES
OF SOUTHWORTH & HAWES, 1843-1862. Boston:
Godine/Rochester: International Museum
of Photography, 1976. 163 pp.; bibliog-
raphy.

107 full-page plates, probably copied
from original prints. Appendices in-
clude a reprint of Gouraud's manual
(see 155) and notes on the firm's plates
and hallmarks.

SUTCLIFFE, FRANK MEADOWS, 1853-1941

308. Hiley, Michael. FRANK SUTCLIFFE, PHOTOG-
RAPHER OF WHITBY. London: Fraser, 1974.
224 pps.; index. (GORDON FRASER PHOTO-
GRAPHIC MONOGRAPHS, 1)

A complete, detailed biography, with
approximately 100 reproductions in the
text and 64 full-page plates. There is
an appendix with notes on the plates.

309. Shaw, Bill E. FRANK MEADOW SUTCLIFFE,
HON. F.R.P.S.: WHITBY AND ITS PEOPLE.
Whitby: Sutcliffe Gallery, 1974. 63 pp.

Mostly reproductions, taken primarily
from prints made from glass negatives.
No explanation is given for the ir-
regular number and letter system for
identifying the photographs, but it
is assumed they represent the Gallery's
own acquisition numbers.

310. Sutcliffe, Frank M. FRANK MEADOW SUT-
CLIFFE. Millerton, NY: Aperture, 1979.
93 pp.; bibliography. (APERTURE HIS-
TORY OF PHOTOGRAPHY, 13).

A brief biographical sketch by Michael
Hiley (see 308), followed by 89 full-
page reproductions.

TALBOT, WILLIAM HENRY FOX, 1800-1877

311. Arnold, Harry. WILLIAM HENRY FOX TAL-
BOT: PIONEER OF PHOTOGRAPHY AND MAN
OF SCIENCE. London: Hutchinson Benham,
1977. 383 pp.; with a list of published
works and papers by Talbot and an index.

A major biography, full of detail, com-
pletely documented, and very well-
written.

312. Booth, Arthur H. WILLIAM HENRY FOX
TALBOT, FATHER OF PHOTOGRAPHY. London:
Barker, 1965. 119 pp.; "suggestions
for further reading," index.

More a survey of the photographic
scene in Talbot's day than a biog-
raphy of Talbot. Some illustrations,
not particularly helpful.

313. Buckland, Gail. FOX TALBOT AND THE IN-
VENTION OF PHOTOGRAPHY. Boston: Godine,

1980. 216 pp.; bibliography, index.

A good survey of Talbot and his work. Includes reproductions of photographs taken by his contemporaries, Calvert Jones and George Bridges. Many illustrations, plus approximately 50 reproductions of Talbot calotypes which mimic their original appearance as regarding state and tint.

314. Jammes, Andre. WILLIAM H. FOX TALBOT, EIN GROSSER ERFINDER UND MEISTER DER PHOTOGRAPHIE. Luzern und Frankfurt a. M.: Bucher, 1972. 96 pp.; index. BIBLIOTHEK DER PHOTOGRAPHIE, 2)

Primarily reproductions. Many included for their value as examples of Talbot's technique (i.e. negatives, early paper prints, microscopic images).

315. Lassam, Robert. FOX TALBOT, PHOTOGRAPHER. Foreword by Sir Cecil Beaton. Tisbury, Eng.: Compton Press/Stanhope, Eng.: Dovecote Press, 1979. 23 pp. of text, plates unnumbered.

Basically insubstantial, both textually and in the quantity and quality of the reproductions. Lassam is the curator of the Fox Talbot Museum in Lacock, and this work seems to be intended for the curious and uninitiated who wander in to the Museum Gift Shop.

316. Talbot, Henry F. SOME ACCOUNT OF THE ART OF PHOTOGENIC DRAWING. London: Taylor, 1839. 13 pp.

"...this 13-page brochure which appeared in February, 1839 constitutes the world's first separate publication

on photography."
--Helmut Gernsheim. THE HISTORY OF
PHOTOGRAPHY (see 27).

317. _____. THE PENCIL OF
NATURE. London: Longman, 1844-6.
24 plates.

Published in six fascicles of four
plates each, with a "brief historic
sketch" (of 24 pp.) in the first.
Each plate is accompanied by a note
from the author concerning the sub-
ject and technique of the photo-
graph. Reprinted in one volume with
an introduction by Beaumont Newhall
by Da Capo, N.Y., in 1969.

TAUNT, HENRY WILLIAM, 1842-1922

318. Brown, Bryan, ed. THE ENGLAND OF HENRY
TAUNT, VICTORIAN PHOTOGRAPHER. London:
Routledge & Kegan Paul, 1973. Unpagi-
nated.

A brief introductory essay followed by
over 150 captioned reproductions of
Taunt's work.

319. Graham, Malcolm. HENRY TAUNT OF OXFORD,
A VICTORIAN PHOTOGRAPHER. Oxford:
Oxford Illustrated Press, 1973. Unpagi-
nated.

A brief biographical sketch followed
by approximately 80 captioned repro-
ductions.

320. Taunt, Henry W. A NEW MAP OF THE RIVER
THAMES FROM OXFORD TO LONDON. Illustra-
ted with eighty photographs. Oxford:
Taunt, 1873. 79 pp.

"...the earliest photographically illustrated guidebook."
--Bryan Brown. THE ENGLAND OF HENRY TAUNT (see 318).

THOMSON, JOHN, 1837-1921

321. Thomson, John. ILLUSTRATIONS OF CHINA AND ITS PEOPLE. 4 vols. London: Sampson Low, 1873/4. 96 plates; unpaginated.

An edited and revised edition of this book was published under the title CHINA: THE LAND AND ITS PEOPLE: EARLY PHOTOGRAPHS in Hong Kong by Warner in 1977; an unabridged reprint was published under the title CHINA AND ITS PEOPLE IN EARLY PHOTOGRAPHS by Dover, N.Y. in 1982.

322. _____. STREET LIFE IN LONDON. Text by Adolphe Smith. London: Sampson Low, 1877. 100 pp.

The original edition contains 30 original photographs by Thomson. The text is concerned with the subjects of the photographs. Reprinted by Benjamin Blom, N.Y. in 1969.

TOURNACHON, GASPARD FELIX, 1820-1910

323. Barret, Andre. NADAR: 50 PHOTOGRAPHIES DE SES ILLUSTRES CONTEMPORAINS. Paris: Tresors de la Photographie, 1975. 155 pp.

A biographical essay followed by full-page portrait plates, including a few by Paul Nadar, his son.

324. Bory, Jean-Francois. NADAR. 2 vols.
Paris: Hubschmid, 1979. 1289 pp.;
separate indexes for each volume.

The first volume contains a brief
introduction and a catalogue of Nadar's
portraits reproduced in a uniform 4" X
6" format, with captions. The second
volume contains reprints of Nadar's
work as a caricaturist and author (LE
DROIT AU VOL, see 328; QUAND J'ETAIS
PHOTOGRAPHE, see 331).

325. Gosling, Nigel. NADAR. N.Y.: Knopf,
1976. 298 pp.; index.

A brief biographical essay followed
by 80 reproductions of Nadar portraits
and selected reproductions of work by
Nadar and his studio. The portraits
are accompanied by full-page biog-
raphies.

326. Greaves, Roger. NADAR, OU LE PARADOXE
VITAL. Paris: Flammarion, 1980. 413 pp.;
bibliography, index.

A complete, scholarly biography.
Surprisingly lacking in illustrations
(there are only two leaves of repro-
ductions).

327. Meyer, Catherine et Bertrand. NADAR:
PHOTOGRAPHE, CARICATURISTE, JOURNALISTE.
Paris: Encre, 1979. 77 pp.

Profiles of Nadar's portrayals of 26
famous Frenchmen, in alphabetical or-
der from Balzac to Alfred de Vigny.

328. Nadar. LE DROIT AU VOL. Paris: Hetzel,
1865. 2 ed. 115 pp.

Nadar was one of the first persons
to conduct photographic experiments
from an aerial balloon. This and his
MEMOIRES DU GEANT (see 329; LE GEANT
was the name of Nadar's wicker, air-
borne car) are his memoirs of these
experiments. LE DROIT AU VOL is re-
printed in the Hubschmid set (see 324).

329. _____. MEMOIRES DU GEANT. Paris:
Dentu, 1865. 2 ed. 439 pp.

See 328.

330. _____. QUAND J'ETAIS ETUDIANT.
Paris: Dentu, 1881. 302 pp.

See 331.

331. _____. QUAND J'ETAIS PHOTOGRAPHE.
Preface de Leon Daudet. Paris: Flam-
marion, 1899. 314 pp.

This title, along with QUAND J'ETAIS
ETUDIANTE (see 330) are Nadar's mem-
oirs of his life. Reprinted in the
Hubschmid set (see 324).

332. Prinet, Jean et al. NADAR. Torino:
Einaudi, 1973. 403 pp.; bibliography.

A biography originally published in
a shorter edition in French in 1966.
This edition, with additional text by
Lamberto Vitali, includes 94 repro-
ductions of Nadar portraits, excerpts
from his writings, and a small selec-
tion of reproductions of work by Nadar's
contemporaries: Adolphe Bertsch, Etienne
Carjat-Salomon, and others.

VANCE, ROBERT H., d. 1876

333. Coulter, Edith M. and Van Nostrand,
     Jeanne. A CAMERA IN THE GOLD RUSH.
     San Francisco: The Book Club of Cali-
     fornia, 1946.

     Twelve plates by Vance.

334. Vance, Robert H. CATALOGUE OF DAGUERREO-
     TYPE PANORAMIC VIEWS IN CALIFORNIA.
     N.Y.: Baker, Godwin, 1851. 8 pp.

     Includes approximately 300 views. The
     photographs themselves are lost.

WATKINS, CARLETON E., 1825-1916

335. Alinder, James, ed. CARLETON E. WATKINS:
     PHOTOGRAPHS OF THE COLUMBIA RIVER AND
     OREGON. Essays by David Featherstone
     and Russ Anderson. Carmel, CA: Friends
     of Photography, 1979. Text unpaginated;
     51 plates.

     Essays on the expedition which produced
     the COLUMBIA RIVER AND OREGON album
     (1872), and on Watkins' work there,
     followed by full-page plates which re-
     produce the contents of the original
     album.

336. Johnson, J.W. THE EARLY PACIFIC COAST
     PHOTOGRAPHS OF CARLETON E. WATKINS.
     (Berkeley, CA): Univ. of California
     Water Resources Center, 1960. 64 pp.

     "This carefully researched paper became
     a landmark document in modern photo-
     graphic history, with a reputation which
     considerably outlasted the availability

of the actual publication."
--Richard Rudisill, in CARLETON E.
WATKINS, ed. by Marilyn Ziebarth (see
337).

337. Ziebarth, Marilyn, ed. CARLETON E. WAT-
KINS. San Francisco: California Histori-
cal Society, 1978. 77 pp., numbered 211-
288. (CALIFORNIA HISTORY, special issue).

Contains six articles on various aspects
of Watkins' work, plus a chronology and
a checklist of Watkins' photographs in
the California Historical Society Li-
brary.

WEDGWOOD, THOMAS, 1771-1805

338. Litchfield, R.B. TOM WEDGWOOD, THE FIRST
PHOTOGRAPHER. London: Duckworth, 1903.
271 pp.; index.

Apologists who do not consider Talbot
distinct enough have seized upon Wedg-
wood as the true inventor of photog-
raphy, although it appears in hind-
sight that he did little more than any-
one else in the burgeoning field of
light research in the 1790's. Gern-
sheim (see 27) grudges Litchfield "an
excellent account of his life and char-
acter" but adds he "was able to contri-
bute little to the knowledge of his
photographic experiments," while for
Eliza Meteyard (see 339) he reserves
a harsher judgment: "...Meteyard made
extravagant and quite unfounded claims
for Wedgwood in her book A GROUP OF
ENGLISHMEN, and this in spite of the
fact that the most glaring of her false
theories had already been completely

exposed several years before."

339. Meteyard, Eliza. A GROUP OF ENGLISHMEN
     (1795 to 1815), BEING RECORDS OF THE
     YOUNGER WEDGWOODS AND THEIR FRIENDS,
     EMBRACING THE HISTORY OF THE DISCOVERY
     OF PHOTOGRAPHY. London: Longmans, 1871.
     416 pp.
     See 338.

EARLY VIEWS & TOPOGRAPHIC SURVEYS

340. Aunay, Alfred d'. LES RUINES DE PARIS
     ET SES ENVIRONS. Paris: Lahure, 1871.
     2 vols.

     Alfred d'Aunay was the pseudonym for
     Alfred Descudier. These volumes include
     100 photographers by Alphonse Liebert,
     primarily known as a chemist and photo-
     graphic inventor.

341. Baldus, Edouard. LES MONUMENTS PRINCI-
     PAUX DE LA FRANCE. Paris: Morel, 1875.
     60 plates.

     "Baldus...became one of the leading
     French architectural photographers of
     the early period."
     --Helmut and Alison Gernsheim. THE
     HISTORY OF PHOTOGRAPHY (see 27).

342. Becchetti, Piero. FOTOGRAFI E FOTOGRAFIA
     IN ITALIA, 1839-1880. Roma: Quasar, 1978.
     320 pp.; index.

     A short essay on the history and develop-
     ment of photography, particularly in

Italy, followed by a dictionary of photographers classified by city and including either address, a biographical sketch, bibliographic data, or just the name, depending upon how much is known. Nearly 100 reproductions--views, genre, and portraits. Includes non-Italian photographers active in Italy.

343. Beers, Burton F. CHINA IN OLD PHOTO-GRAPHS, 1860-1910. N.Y.: Scribner, 1978. 160 pp.

A short essay followed by 165 reproductions, classified by subject and fully captioned.

344. Betjeman, John. VICTORIAN AND EDWARDIAN LONDON FROM OLD PHOTOGRAPHS. Introduction and commentaries by John Betjeman. N.Y.: Viking, 1969. Unpaginated; 208 photographs.

Primarily reproductions, classified by subject.

345. Beveridge, Erskine. WANDERINGS WITH A CAMERA, 1882-1898. 2 vols. Edinburgh: Brown, 1922. 313 pp. of plates.

Views of Scotland.

346. Bleignerie, H. de et Dangin, Edouard. PARIS INCENDIE, 1871: ALBUM HISTORIQUE. Paris: Jarry, 1871.

Two essays on the Seige, followed by original photographs illustrating monuments and scenes in Paris. Two full-page plates and 28 miniatures (3" X 2"). The photographers are not credited but according to Gernsheim (see 27), they may be, in part, by Nadar or Disderi.

347. Bramsen, Henrik et al. EARLY PHOTO-
     GRAPHS OF ARCHITECTURE AND VIEWS IN
     TWO COPENHAGEN LIBRARIES. Copenhagen:
     Thaning & Appel, 1957. 92 pp.; index
     of places.

     A brief introduction followed by a
     dictionary of photographers. All major
     view photographers of Europe are in-
     cluded; each entry provides biographi-
     cal details, some bibliographic infor-
     mation, and a catalogue of the holdings
     of the libraries: the Royal Library
     Department of Maps and Prints and the
     Library of the Royal Academy of Fine
     Arts. Approximately 50 reproductions.

348. Billeter, Erika. FOTOGRAFIE LATEIN-
     AMERIKA. Bern: Benteli, 1981. 416 pp.;
     bibliography.

     Divided equally between 19th and 20th
     century artists, it documents an area
     all too frequently ignored by photo-
     graphic historians. The 19th century
     material includes mostly wide views
     and ethnographic documentation.

349. Black, Mary. OLD NEW YORK IN EARLY
     PHOTOGRAPHS, 1853-1901. N.Y.: Dover,
     1973. 228 pp.

     196 reproductions from the collection
     of the New York Historical Society,
     classified by district (i.e. The Bat-
     tery, Broadway north to the Brooklyn
     Bridge, etc.). The photographs are
     captioned, and credited wherever the
     photographer is known.

350. Cannon, Michael. AN AUSTRALIAN CAMERA,
     1851-1914. Newton Abbot: David & Charles,
     1973. 112 pp.

The text is comprised mainly of ex-
tended captions; the photographs are
classified by general subjects such
as "Convict Era," "The Far Outback,"
and "Sports and Pastimes."

351. Chandler, George. VICTORIAN AND EDWARD-
IAN LIVERPOOL AND THE NORTH WEST FROM
OLD PHOTOGRAPHS. London: Batsford, 1972.
149 plates.

Entirely reproductions, classified by
subject (i.e. "Liverpool the Port,"
"Country Life," "Transport").

352. Collins, Leonora, ed. LONDON IN THE
NINETIES. London: Saturn Press, 1950.
96 pp.

Excerpts from contemporary authors,
poets, and journalists with approximate-
ly 80 reproductions. The photographs are
uncredited.

353. Coppens, Jan (and) Alberts, A. EEN
CAMERA VOL STILE: NEDERLAND IN HET
BEGIN VAN DE FOTOGRAFIE, 1839-1875.
Amsterdam: Meulenhoff, 1976. 317
photographs; unpaginated.

Two short essays, with reproductions
classified by general subjects.

354. Current, Karen. PHOTOGRAPHY AND THE
OLD WEST. Photographs selected and
printed by William R. Current. N.Y.:
Abrams, 1978/in association with the
Amon Carter Museum of Western Art,
Ft. Worth, TX. 272 pp.; bibliography,
index.

172 plates. Biographical essays on and
examples from Watkins, William A. Bell,

O'Sullivan, Muybridge, Hillers, and Jackson, plus smaller, subject-oriented pieces on one dozen other photographers, including Russell. Includes bibliographic notes.

355. Davies, George C. NORFOLK BROADS AND RIVERS. Edinburgh: Blackwood, 1883. 290 pp.

"...a compelling and comprehensive description of the life and landscape of the Broads..."
--C.S. Middleton. THE BROADLAND PHOTOGRAPHERS (see 236).

This edition contains twelve original photographs by Davies.

356. _____. ON DUTCH WATERWAYS: THE CRUISE OF THE S.S. ATLANTA ON THE RIVERS AND CANALS OF HOLLAND & THE NORTH OF BELGIUM. London: Jarrold, 1886. 379 pp.

Includes photogravures by Thomas Annan and Joseph W. Swan.

357. Davidson, James B. THE CONWAY IN THE STEREOSCOPE. London: Reeve, 1860. 187 pp.

20 leaves of plates by Roger Fenton. The Conway flows through northern Wales into the Irish Sea.

358. Davis, Lynn. NA PA'I KI'I: THE PHOTOGRAPHERS IN THE HAWAIIAN ISLANDS, 1845-1900. Honolulu: Bishop Museum Press, 1980. 48 pp. (BISHOP MUSEUM SPECIAL PUBLICATIONS, 69.)

Published in conjunction with an exhibition at the Museum. Text includes

several essays on early photography
in Hawaii. Approximately 30 plates,
mostly by Christian J. Hedemann, Hugo
Stangewald, and Charles L. Weed.

359. Davis, William C., ed. THE IMAGE OF
WAR, 1861-1865. (In progress). Garden
City, NY: Doubleday, 1981-   . Includes
indexes.

An attempt to update, augment, and
correct Miller's work (see 384). Pro-
jected at 6 vols. To date: I. Shadows
of the storm, 1981. II. The guns of
'62, 1982. III. The embattled confede-
racy, 1982. These volumes include
essays, each followed by approximately
50 reproductions. The photographers are
largely anonymous.

360. Dellenbaugh, Frederick S. A CANYON
VOYAGE: THE NARRATIVE OF THE SECOND
POWELL EXPEDITION...IN 1871 AND 1872.
N.Y.: Putnam, 1908. 277 pp.; index.

50 photographic reproductions, mostly
by E.O. Beaman, the rest by Hillers
and others. A new edition was published
by Yale Univ. Press, New Haven & London,
in 1962.

361. Donnachie, Ian and MacLeod, Innes.
VICTORIAN AND EDWARDIAN SCOTTISH LOW-
LANDS FROM HISTORIC PHOTOGRAPHS. Lon-
don: Batsford, 1979. 119 pp.

Mostly reproductions, with captions.
Classified by subject, i.e. "By the
sea shore," "Children at work and play."
No credits.

362. DuCamp, Maxime. EGYPTE, NUBIE, PALES-
     TINE ET SYRIE. Paris: Gide et Baudry,
     1852. 125 plates.

     "...one of the best-known French pub-
     lications illustrated with original
     photographs...(but) neither the colour
     nor the quality of the prints can com-
     pare in beauty with the warm, reddish-
     brown colour of the calotype prints
     produced by Hill and Adamson."
     --Helmut and Alison Gernsheim. THE
     HISTORY OF PHOTOGRAPHY (see 27).

363. Fabian, Rainer and Adam, Hans-Christian.
     MASTERS OF EARLY TRAVEL PHOTOGRAPHY.
     London: Thames and Hudson, 1983. 352 pp.;
     bibliography.

     An extraordinary work of craftsmanship.
     Over 200 full-page prints, reproduced
     in the original tint or color, classi-
     fied by geographic region. Includes
     work by Niepce, Frith, Felice Beato,
     Marc Ferrez, Bourne, Thomson, Jackson,
     Watkins, and one dozen others. Essays
     introduce each chapter, and an appendix
     includes brief biographies of the art-
     ists.

364. Feininger, Andreas. THE FACE OF NEW YORK:
     THE CITY AS IT WAS AND AS IT IS. Text
     by Susan B. Lyman. N.Y.: Crown, 1954.
     Unpaginated.

     Early photographs of the city and its
     environs laid out in proximity to re-
     cent photographs of the same locations
     taken by Feininger.

365. Fergusson, James. ONE HUNDRED STEREO-
     SCOPIC ILLUSTRATIONS OF ARCHITECTURE

AND NATURAL HISTORY IN WESTERN INDIA,
PHOTOGRAPHED BY MAJOR GILL. London:
Cundall, Downes, 1864.

Fergusson was one of the great writers
on architecture in the 19th century.

366. Frassanito, William A. ANTIETAM: THE
PHOTOGRAPHIC LEGACY OF AMERICA'S
BLOODIEST DAY. N.Y.: Scribner, 1978.
304 pp.; bibliography, index.

A scholarly study of the photography
and photographers present at Antietam.
The author groups his photographers
by their geographical situation on the
battlefield, and carefully identifies
each person and image whenever possible.
Approximately 60 reproductions are
accompanied by the author's battle
reports and historical notes. An
exemplary work.

367. _____. GETTYSBURG:
A JOURNEY IN TIME. N.Y.: Scribner,
1975. 248 pp.; index.

The same as item 366, for Gettysburg.

368. George, Hereford B. THE OBERLAND AND
ITS GLACIERS, EXPLORED AND ILLUSTRATED
WITH ICE-AXE AND CAMERA. With twenty-
eight photographic illustrations by
Ernest Edwards. London: Bennett, 1866.
243 pp.

Includes "notes by the photographer."
The Oberland is in the Swiss Alps,
ranging south of Berne.

369. Godwin-Ternbach Museum at Queens College
(New York). UN VOYAGE HELIOGRAPHIQUE A

FAIRE: THE MISSION OF 1851, THE FIRST
PHOTOGRAPHIC SURVEY OF HISTORICAL MONU-
MENTS IN FRANCE. 4 March-3 April, 1981.
N.Y.: Godwin-Ternbach Museum, 1981.
37 pp.

Selections from the work of the Societe
Heliographique, formed in Paris in 1851
to photograph the principal historical
monuments of France. Almost every notable
French photographer of the day was in-
volved; the catalogue of this exhibi-
tion concentrates on Baldus, Le Secq
Le Gray, and O. Mestral. 83 works are
catalogued, but only a dozen or so are
reproduced as accompaniment to an essay
on the missions.

370. Gorham, Maurice. IRELAND FROM OLD PHOTO-
GRAPHS. London: Batsford, 1971. 160 pp.

205 reproductions, classified by sub-
jects such as "On the road," "Work,"
and "Art and learning."

371. Gutch, J.W. PHOTOGRAPHIC ILLUSTRATIONS
OF SCOTLAND. (s.l.:s.n.), 1857. 50
leaves of plates.

A rare, early collection of views.
Calotypes.

372. Hershkowitz, Robert. THE BRITISH PHOTOG-
RAPHER ABROAD: THE FIRST THIRTY YEARS.
London: Hershkowitz, 1980. 95 pp.

Plates of views by Jones, Bridges,
Sutton, Fenton, Beato, Frith, Bed-
ford, Bourne, Thomson, and others.
A brief, general essay follows.

373. Howitt, William and Mary. RUINED ABBEYS
     AND CASTLES OF GREAT BRITAIN. Photo-
     graphic illustrations by Bedford, Sedg-
     field, Wilson, Fenton, and others.
     London: Bennett, 1862. 228 pp.

     26 original photographs in a reduced
     format. A second series was published
     in 1864, also with 26 photographs. The
     "others" include Thomas Ogle, S. Thomp-
     son, and a Dr. Hemphill.

374. Hubmann, Franz, ed. DAS DEUTSCHE FAMI-
     LIENALBUM: DIE WELT VON GESTERN IN
     ALTEN PHOTOGRAPHIEN VON DER ROMANTIK
     ZUM ZWEITEN KAISERREICH. Text von
     Janko Musulin. Wien: Molden, 1972.
     336 pp.

     Mostly views and group portraits, ar-
     ranged chronologically and dating to
     the advent of the First World War.
     Credits given when known.

375. Kneeland, Samuel. THE WONDERS OF THE
     YOSEMITE VALLEY AND OF CALIFORNIA.
     With original photographic illus-
     trations by John P. Soule. Boston:
     Moore, 1871. 71 pp.

     Includes 10 mounted photographs.

376. Kocher, A. Lawrence and Dearstyne,
     Howard. SHADOWS IN SILVER: A RECORD
     OF VIRGINIA, 1850-1900 IN CONTEM-
     PORARY PHOTOGRAPHS. N.Y.: Scribner,
     1954. 264 pp.; index.

     Photographs by George Cook (1819-1902)
     and Huestis Cook (1868-1951), with
     many additions from the Cook family's
     private collection. Only the first
     chapter of the text concerns the Cooks;

the rest is a survey of Virginia social history illustrated by Cook photographs. Approximately 250 reproductions.

377. Lacan, Ernst. ESQUISSES PHOTOGRAPHIQUES. Paris: Grassart, 1856. 219 pp.

Lacan was the editor of LA LUMIERE, the first French photographic journal, from 1851 (still in its first year) to 1860.

378. La Garenne, Paul de la, et al. EXCURSIONS DAGUERRIENNES: VUES ET MONUMENTS LES PLUS REMARQUABLES DU GLOBE. 2 vols. Paris: Rittner et Goupil, 1840/1.

Text by various authors. N.P. Lerebours "equipped a number of artists and writers with daguerreotype outfits of his own manufacture...and commissioned them to take views of France, Italy, Spain, Greece, Egypt, Nubia, Palestine, and Syria."
--Helmut and Alison Gernsheim. THE HISTORY OF PHOTOGRAPHY (see 27).

Approximately 100 of these daguerreotypes were copied as copperplate engravings for publication, thus constituting the first book to be illustrated with engravings based on photographs.

379. Lefuel, Hector M. PALAIS DU LOUVRE ET DES TUILERIES. Heliogravure par E. Baldus. Paris: Morel, 1875. 3 vols.; 300 plates.

See 341.

380. Lejko, Krystyna (and) Niklewska, Jolanta. WARSZAWA NA STAREJ FOTOGRAFII, 1850-1914. Warszawa: Panstwowe Wydawnictwo Naukowe, 1978. 270 pp.; bibliography.

A brief essay, a catalogue of nearly
1000 photographs in Polish collections,
and 82 reproductions, mostly portraits
and views.

381. Mangan, Terry W. COLORADO ON GLASS:
COLORADO'S FIRST HALF-CENTURY AS SEEN
BY THE CAMERA. Denver: Sundance, Ltd.,
1975. 406 pp.; bibliography, extensive
directory of photographers.

A vast, unnumbered collection of plates
with the text interspersed. The author
acknowledges the photographer whenever
known, and the appendix lists the names
and towns of nearly 1000 photographers
placed in Colorado between 1853 and
1900.

382. Mayer-Wegelin, Eberhard. FRUHE PHOTO-
GRAPHIE IN FRANKFURT AM MAIN, 1839-
1870. Munchen: Schirmer/Mosel, 1982.
74 pp. + 122 plates; bibliography.

An excellent selection of portraits,
views, and architecture.

383. McClelland, James. JOURNAL OF A VISIT
TO INDIA AND THE EAST. Glasgow: Macle-
hose, 1877. 183 pp.

16 plates. Not available for annotation.

384. Milhollen, Hirst D. and Mugridge, Donald
H. CIVIL WAR PHOTOGRAPHS, 1861-1865.
A catalogue of copy negatives made from
originals selected from the Mathew B.
Brady Collection in the Prints and Pho-
tographs Division of the Library of
Congress. Washington, D.C.: Library of
Congress, 1961. 74 pp.; indexes of
subjects and photographers.

A brief essay followed by an order list
of over 1000 available negatives from
which you can order prints, classified
by subject. Includes work by Barnard,
Brady and his assistants, Gardner, O'Sul-
livan, and others.

385. Miller, Francis T., ed. PHOTOGRAPHIC
HISTORY OF THE CIVIL WAR. 10 vols.
N.Y.: Review of Reviews Company, 1911.
Pages and reproductions unnumbered.

"With thousands of photographs all
reproduced from original prints, and
excellent text written, often, by men
who fought the war, [this history] in-
stantly became the standard that no
work has since excelled. Nevertheless,
while the passing of seven decades has
not diminished the achievement of Mil-
ler and his associates, it has serious-
ly dated their published work...Miller's
editors were not historians. They were
prone to accept fanciful identifications.
The result is that scores, if not hun-
dreds, of the images they reproduced
are printed over erroneous captions..."
--William C. Davis. THE IMAGE OF WAR
(see 359).

386. Nostitz, Grigorii I. PHOTOGRAPHIES DU
COMTE NOSTITZ. Vienne: Blachinger, 1896.
16 leaves of plates.

Views of Moscow. Text in Russian &
French.

387. Sandler, Martin W. THIS WAS NEW EN-
GLAND: IMAGES OF A VANISHED PAST. Bos-
ton: New York Graphic Society, 1977.
222 pp.

Photographs of New England and New
Englanders classified by general sub-
jects such as "The Sea" or "Work."
Each subject is introduced by a one-
page essay. The photographers are
identified when known but there is no
index.

388. Schiller, Ely. THE FIRST PHOTOGRAPHS OF
JERUSALEM: THE OLD CITY. Jerusalem:
Ariel, 1978. 252 pp.; bibliography.

Mostly reproductions. The introductory
essay, list of photographs, and cap-
tions are in English and Hebrew.

389. Seddon, John P. RAMBLES IN THE RHINE
PROVINCES. London: Murray, 1868.
156 pp.

"The Architectural Photographic Asso-
ciation (of London)...chose the Rhine-
land for its first tour, which was
organized almost on the lines of a
military operation...the account of
the tour published the same year, 1868,
was illustrated with only fourteen
photographs, all by John P. Seddon."
--Helmut and Alison Gernsheim. THE
HISTORY OF PHOTOGRAPHY (see 27).

390. Smith, Margaret D. and Tucker, Mary L.
PHOTOGRAPHY IN NEW ORLEANS: THE EARLY
YEARS, 1840-1865. Baton Rouge and Lon-
don: Louisiana State Univ. Press, 1982.
194 pp.; bibliography, index.

A very good, detailed history, with
88 small-scale reproductions and illus-
trations. The appendix includes a bio-
graphical checklist of New Orleans
photographers.

391. Smyth, Charles P. TENERIFFE, AN ASTRON-
OMER'S EXPERIMENT: OR, SPECIALTIES OF
A RESIDENCE ABOVE THE CLOUDS. London:
Reeve, 1858. 451 pp.

The results of Smyth's scientific ex-
periments on Teneriffe, one of the
Canary Islands, conducted in 1856.
Illustrated with 20 original stereo-
graphs.

392. Soulier, Charles S. PARIS-NEUF, OU REVE
ET REALITE. Paris: Barba, 1861. 211 pp. +
8 leaves of plates.

Includes albumen prints of Paris.

393. Steinfeldt, Cecilia. SAN ANTONIO WAS:
SEEN THROUGH A MAGIC LANTERN. Views
from the slide collection of Albert
Steves, Sr. San Antonio, TX: San
Antonio Museum Association, 1978.
245 pp.; bibliography, index.

Includes 250 plates taken from the orig-
inal lantern slides. The text deals
with the history of San Antonio.

394. Stevens, Thomas. THROUGH RUSSIA WITH
THE KAMARET. Boston: Blair Camera Co.,
1891. 30 pp.

The author was a popular travel writer.

395. Thorvaldsen Museum (Copenhagen). ROME
IN EARLY PHOTOGRAPHS: THE AGE OF PIUS
IX--PHOTOGRAPHS, 1846-1878, FROM
ROMAN AND DANISH COLLECTIONS. Trans.
by Ann Thornton. Copenhagen: Thorvald-
sen Museum, 1977. 482 pp.; bibliography,
index.

Introductory essays, followed by a
biographical listing of photographers
in Rome and 210 full-page plates with
detailed captions on the facing pages.

396. Ware, James R. THE ISLE OF WIGHT. Photo-
graphic illustrations by Russell Sedg-
field and Frank M. Good. London: Provost,
1869. 182 pp.

Not available for annotation.

397. Warner, John. FRAGRANT HARBOUR: EARLY
PHOTOGRAPHS OF HONG KONG. Hong Kong:
Warner Publications, 1976. 192 pp.

203 reproductions, with text and captions
in English and Chinese.

398. Watson, Wendy M. IMAGES OF ITALY: PHOTOG-
RAPHY IN THE NINETEENTH CENTURY. Pub-
lished in conjunction with an exhibition
at the Mount Holyoke College Art Museum,
South Hadley, MA, Feb. 8-March 14, 1980.
South Hadley: Trustees of Mount Holyoke
College, 1980. 71 pp.

A good introductory essay on the practice
of photography in Italy in the 19th cen-
tury, followed by 100 reproductions grouped
by artist. Includes work by Fratelli Ali-
nari, Bisson Freres, Giacomo Brogi, Alex-
ander Ellis, Calvert Jones, Robert Mac-
Pherson, Carlo Ponti, and others.

399. Wilson, George W. PHOTOGRAPHS OF EN-
GLISH AND SCOTTISH SCENERY: BALMORAL.
Aberdeen: Wilson, 1866. 12 plates.

Others in this series, also featuring one
dozen albumen plates, include: BRAEMAR
(1866), ENGLISH CATHEDRALS: YORK AND DUR-
HAM (1865), DUNKELD (1866),

and TROSSACHS AND LOCH KATRINE (1866).
Also, published by Marion, London:
EDINBURGH (1868), STAFFA & IONA (1867),
and THE CALEDONIAN CANAL (1867).

400. Worswick, Clark and Embree, Ainslie.
THE LAST EMPIRE: PHOTOGRAPHY IN BRITISH
INDIA, 1855-1911. Preface by the Earl
Mountbatten of Burma. Millerton, NY:
Aperture, 1976. 146 pp.; bibliography.

Plates unnumbered but identified when-
ever possible. A good mix of portraits,
architecture, and landscapes.

ADDENDUM

401. Coar, Valencia H. A CENTURY OF BLACK
PHOTOGRAPHERS: 1840-1960. Providence,
RI: Rhode Island School of Design
Museum of Art, 1983. 192 pp.; bibliog-
raphy.

Published in conjunction with a travel-
ling exhibition sponsored by the Rhode
Island School of Design. An important
work, documenting the almost ignored
contributions of black Americans to the
history of photography. Includes 150
very fine reproductions, a third of
which pre-date 1900. Some of the fea-
tured photographers include J.P. Ball,
Alexander Thomas, and the Goodridge
Brothers. There is an appendix with
the names of over 100 black photographers
not included in the exhibition.

402. Greenhill, Ralph. EARLY PHOTOGRAPHY IN
CANADA. Toronto: Oxford Univ. Press,
1965. 173 pp.; bibliography, index.

An account of the development of photog-
raphy in Canada, followed by a selec-
tion of full-page reproductions by H.L.
Hime, Notman, and others, all identified.

403. Newhall, Beaumont. ON PHOTOGRAPHY: A
SOURCE BOOK OF PHOTO HISTORY IN FAC-
SIMILE. Watkins Glen, NY: Century House,
1956. 192 pp.

Reproduces texts by Dickens, Baudelaire,
and Cruikshank as well as others in the
field. More than half the entries pre-
date 1900.

404. Pare, Richard. PHOTOGRAPHY AND ARCHI-
TECTURE, 1839-1939. Introduction by
Phyllis Lambert. Montreal: Canadian
Centre for Architecture, 1982. 282 pp.;
bibliography, index.

Published in conjunction with a travel-
ling exhibition sponsored by the Cana-
dian Centre. Nearly two thirds of the
plates are pre-1900. An appendix in-
cludes biographical sketches of the
photographers, many of whom are not
represented elsewhere: Samuel Bemis,
Breton Freres, Adolphe Braun, James
Anderson, Charles Weed, and many others.

405. Roegiers, Patrick. LE VISAGE REGARDE,
OU LEWIS CARROLL, DESSINATEUR ET PHO-
TOGRAPHE: ESSAI. Paris: Creatis, 1982.
143 pp.

The reproductions are small and not

particularly good, but the essays are
thoughtful and full of detail.

406. Rosenblum, Naomi. A WORLD HISTORY OF
     PHOTOGRAPHY. N.Y.: Abbeville Press, 1984.
     671 pp.; bibliography, index.

     A good survey, with over 800 repro-
     ductions, many in color. Only the first
     third of the book is concerned exclu-
     sively with the 19th century.

407. Weaver, Mike. JULIA MARGARET CAMERON,
     1815-1879. London: Herbert Press, 1984.
     160 pp.; bibliography.

     A brief biography with 140 reproductions
     and illustrations, followed by an appen-
     dix with a selection of Mrs. Cameron's
     poetry, a letter, and ANNALS OF MY GLASS
     HOUSE.

408. Zuchold, Ernst A. BIBLIOTHECA PHOTOGRAPH-
     ICA. Leipzig: Selbstverlag des Verfassers,
     1860. 28 pp.

     The first separately published bibliog-
     raphy on photography. Includes over
     250 items in French, German, and English,
     with sizes and prices. Reprinted by
     Ikaros Forlag, Oslo, in 1977.

409. Ludgers, Ferdinand. DAS DAGUERREOTYPE:
     EIN AUSFUHRLICHE BESCHREIBEN DER DA-
     GUERR'SCHEN METHOD. Quedlinburg: Basse,
     1839.

     Apparently the first book written in
     German on photography. Very rare.

# INDEX

All authors have been indexed. Subjects
rather than titles have been chosen for
secondary references, the theory being
that the reader would more greatly bene-
fit with an index which groups books by
subject matter. All names mentioned in
the citations and annotations which have
any bearing on the content of the book
are also indexed, as are cities and
countries when they are the subject of
a book. References are to item, not
page numbers.

Abbott, Berenice, 193
Abney, William de W., 1, 176, 180
Adam, Hans-Christian, 363
Adams, Ansel, 290, 295
Adams, W.I. Lincoln, 189
Adamson, Robert, 250-254
Adhemar, Jean, 279
aerial photography, 69, 77, 328, 329
Africa, 243, 362
Agnew, William, 239
Alberts, A., 353
albumen processes, see: collodion pro-
cesses
Alfred Steiglitz Center/Philadelphia
Museum of Art, 37, 291
Alinari Brothers, 398
Alinder, James, 335
Alland, Alexander, Sr., 295
Almansi, Guido, 230
ambrotypes, see: collodion processes
American Indians, 223-225, 257
American Photographical Society, 16
Anderson, Elbert, 76
Anderson, James, 404

Anderson, Russ, 335
Annan, Thomas, 191, 192, 356
Anthony, Edward, 38, 43, 58
Anthony, Henry T., 38, 43
Appel, Odette M., 307
Archer, Frederick S., 127
Architectural Photographic Association of
  London, 389
Armfield, Chas. N., 187
Arnold, Harry, 311
Art Institute of Chicago, 115
Atget, Eugene, 193-197
Auer, Michel, 118
Aunay, Alfred d', see: Descudier, Alfred
Australia, 350
Austria, 22

Baldus, Edouard, 341, 369, 379
Balfour, Graham, 187
Ball, J.P., 401
Baltzly, Benjamin, 198
Barley, M.W., 2
Barnard, George N., 199, 384
Barret, Andre, 323
Bassham, Ben L., 304
Batut, Arthur, 77
Baudelaire, Charles, 403
Bayard, Hippolyte, 200, 206
Beaman, E.O., 360
Beato, Felice, 363, 372
Beaton, Cecil, 269, 315
Beccaria, Giacomo B., 18
Becchetti, Piero, 342
Bedford, Francis, 201, 202, 372, 373
Beers, Burton F., 343
Belgium, 356
Bell, William, 292, 354
Belloc, Auguste, 78, 128
Bemis, Samuel, 404
Bertsch, Adolphe, 332

Betjeman, John, 344
Beveridge, Erskine, 345
Bibliotheque Nationale (Paris), 3
Billeter, Erika, 348
Bisbee, Albert, 150
Bisson Freres, 398
Black, Mary, 349
black photographers, 401
Blair, Thomas H., 38
Blanquart-Evrard, Louis D., 203-206
Bleignerie, H. de, 346
Boord, W.A., 187
Booth, Arthur H., 312
Borcoman, James, 278
Bory, Jean-Francois, 324
Boston, 306
Bourne, Samuel, 207,363, 373
Boussel, Patrice, 4
Brady, Mathew B., 208-214, 384
Bramsen, Henrik, 347
Brassai, 231
Braun, Adolphe, 404
Brebisson, Alphonse de, 129
Breton Freres, 404
Brettell, Richard R., 115
Brewster, David, 181
Bridges, George, 313, 372
Britt, Peter, 214
Broecker, William L., 265
Brogi, Giacomo, 398
Brown, Bryan, 318
Browne, Turner, 5
Bruce, David
Buberger, Joe, 303
Buckland, Gail, 6, 313
Buehler, Otto, 79
Bunnell, Peter C., 293
Burgess, Nathan G., 130
Buron, 151

California, 334, 375

California Historical Society, 337
Calmette, Louis, 135
calotypes, 115-117, 250, 251, 254
camera history, 118-121
camera obscura, 34
Cameron, Julia M., 48, 187, 215-219, 407
Cameroon, H.H. Hay, 216
Canary Islands, 391
Cannon, Michael, 350
Carjat-Salomon, Etienne, 332
Canada, 198
carbon processes, 122-126
Carroll, Lewis, see: Dodgson, Charles L.
Cecil, David, 218
Chadwick, William J., 169
Chandler, George, 351
Chardon, Alfred, 166
Charnay, Desire, 220
Chevalier, Arthur, 221
Chevalier, Charles L., 80, 81, 152, 153,
  221
China, 321, 343
Civil War, 213, 247, 303, 359, 366, 367,
  384, 385
Clark, Lyonel, 176
Claudet, Antoine F., 182
Coale, George B., 82
Coar, Valencia H., 401
Coe, Brian, 7,8,9,119
Coleman, A.D., 224
Collard, Edgar A., 287
Collins, Leonora, 352
collodion processes, 127-134
collotypes, see: gelatin emulsion pro-
  cesses
Colnaghi & Co. (London), 10
color photography, 135-149
Colorado, 260, 264, 381
Cook, George, 376
Cook, Huestis, 376

Coppens, Jan, 353
Cornelius, Robert, 62
Coulter, Edith M., 333
Chretien, Gilles-Louis, 111
Crawford, William, 11
Crimea, 239
Cros, Charles, 136, 140
Cruikshank, George, 403
Crystal Palace (London), 84
Current, Karen, 354
Current, William R., 354
Curtis, Edward S., 223-225

Daguerre, Louis J.M., 51, 159, 226-229
daguerreotypes, 150-165
Dallmeyer, Thomas R., 83
Dangin, E., 346
Darrah, William C., 183
Daudet, Leon, 331
Davanne, Alphonse, 13
Davidson, James B., 357
Davies, George C., 236, 355, 356
Davis, Keith F., 220
Davis, Lynn, 358
Davis, William C., 359
Davison, George, 187
Dearstyne, Howard, 376
Delamotte, Philip H., 84
Dellenbaugh, Frederick S., 360
Deloria, Vine, Jr., 225
Descudier, Alfred, 340
Despaquis, 122
Dexter, R.F.M., 12
Dickens, Charles, 403
Dillaye, Frederic, 167
Dingus, Rick, 288
Disderi, A.A., 14, 346
Dodgson, Charles L., 48, 218, 230-231,
  405
Doherty, Robert J., 296

Dolan, Edward F., Jr., 15
Donnachie, Ian, 361
Draper, John W., 16
Driggs, Howard R., 261
Drouin, Felix, 141
dry plates, see: gelatin emulsion
 processes
Duboscq, J., 131
DuCamp, Maxime, 362
Ducos du Hauron, Alcide, 137, 139
Ducos du Hauron, Louis, 136-140
Dumoulin, Eugene, 140
Duncan, Robert G., 43
Dworschak, Fritz, 233

early technical treatises, 76-186
early theoretical treatises, 187-190
early views & topographical surveys,
 340-400
Eastman, George, 8, 39, 232
Eder, Joseph M., 17, 18, 85, 168, 233
Edkins, Diana E., 265
Edwards, Ernest, 368
Egerton, J., 154
Egypt, 242-244, 246, 362
Eigsti, Mary S., 3
Elliott, Andrew, 251
Ellis, Alexander, 398
Embree, Ainslie, 400
Emerson, Peter H., 187, 234-238
England, 65, 245, 351, 396, 399
 see also: Great Britain
Epstean, Edward, 17, 19, 51, 282
Ernault, Armand, 143
Ernouf, Alfred A., 20
Estabrooke, Edward M., 185

Fabian, Rainer, 363
Fabre, Charles, 21
Fabricius, Georg, 18

Featherstone, David, 335
Feininger, Andreas, 364
Fenton, Roger, 239, 240, 357, 372, 373
Fergusson, James, 365
Ferrez, Marc, 363
ferrotypes, see: tintypes
Fine Arts Gallery, New York State Univ.
 College (Brockport, NY), 202
Finley, Marshall, 87
Fisher, George T., 88
Fitzgibbon, John H., 241
Flukinger, Roy, 268
Ford, Colin, 217, 252
Forsee, Aylesa, 258
Fouque, Victor, 282
Fowler, Don D., 255
Fraenkel, Helene E., 253
France, 3, 23, 61, 115, 116, 341, 369
Frank, Hans, 22
Frankfurt A.M., 382
Frassanito, William A., 366, 367
Freund, Gisele, 23, 24
Frith, Francis, 202, 242-246, 363, 372
Fry, Roger, 215

Gale, J., 187
Gamble, William B., 142
Gardner, Alexander, 247, 384
Gassan, Arnold, 25
Gassmann, Pierre, 195
Gaudin, Marc A., 89, 154
gelatin emulsion processes, 166-168
general works, 1-75
George, Hereford B., 368
Germany, 50, 158, 374, 389, 409
Gernsheim, Alison, 27, 227, 239
Gernsheim, Helmut, 26, 27, 219, 227, 230,
 231, 239
Geymet, Theophile, 90, 177
Gilardi, A., 28
Gilbert, George, 29, 120

Gill, Major, 365
Gioppi, Luigi, 91
Godwin-Ternbach Museum at Queens College
　(New York), 369
Goldberg, Vicki, 30
Goldschmidt, Lucien, 31
Good, Frank M., 396
Goodall, T.F., 234
Goodridge Brothers, 401
Gorham, Maurice, 370
Gorsline, Douglas, 258
Gosling, Nigel, 325
Gouraud, Jean-Baptiste, 155, 307
Graham, Malcolm, 319
Great Britain, 2, 26, 37, 55, 115, 373
　see also: England, Ireland, Scotland,
　Wales
Great Exhibition of 1851
　see: Crystal Palace (London)
Greaves, Roger, 326
Guerronnan, Anthonny, 32
Gutch, J.W., 371
Gutman, Judith M., 33

Haas, Robert B., 272
Halleur, G.C., 92
Hambourg, Maria M., 197
Hammond, John H., 34
Hannavy, John, 35, 240
Hardwich, Thomas E., 132
Harmant, Pierre G., 284
Harper, J. Russell, 287
Harrad, Alfred, 203
Harrison, W. Jerome, 36
Harvard, Charles, 270
Harvey, P.D.A., 2
Hassner, Rune, 297
Hawaii, 358
Hawes, Josiah J., 306, 307
Haworth-Booth, Mark, 9, 37

Haynes, F. Jay, 248, 249
Hedemann, Christian J., 358
heliography, 105
Hemphill, Dr., 373
Hendricks, Gordon, 273
Hepworth, Thomas C., 170, 171
Herschel, John F., 93, 217
Hershkowitz, Robert, 372
Hiley, Michael, 308
Hill, David O., 250-254
Hill, Levi L., 156
Hillers, John K., 255-257, 354, 360
Hockin, John B., 94
Hodge, Frederick W., 223
Homer, Rachel J., 306
Hong Kong, 397
Horan, James D., 209, 289
Hoobler, Dorothy, 208
Hoobler, Thomas, 208
Howitt, Mary, 373
Howitt, William, 373
Huberson, G., 179
Hubl, Arthur, 178
Hubmann, Franz, 374
Humphrey, Samuel D., 87, 133, 157
Hunt, Robert, 95, 96

India, 33, 207, 365, 383, 400
International Museum of Photography
 (Rochester, NY), 121
Ireland, 370
Iselin, J.F., 178
Isenberg, Matthew, 303
Israel
 see: Palestine
Italy, 342, 398

Jackson, Clarence S., 259
Jackson, William H., 258-266, 354, 363

Jammes, Andre, 116, 200, 279, 314
Jammes, Isabelle, 206
Janis, Eugenia P., 116
Jay, Bill, 245, 269
Jenkins, Reese V., 38
Jennings, J. Payne, 236, 267
Jerusalem, 388
Johnson, J.W., 336
Jones, Bernard E., 39
Jones, Calvert, 313, 372, 398
Jones, Edgar Y., 294
Jones, Elizabeth B., 264
Jones, William C., 264

Kempe, Fritz, 158
Ken, Alexandre, 40
Kneeland, Samuel, 375
Kocher, A. Lawrence, 376
Krumpel, Otto, 233
Kunhardt, Dorothy M., 210
Kunhardt, Philip B., Jr., 210

La Blanchere, Henri M. de la, 41, 97, 184
Lacan, Ernst, 377
La Garenne, Paul de, 378
Lambert, F.C., 187
Lambert, Phyllis, 404
landscape photography, see: photography
  as a fine art
Lassam, Robert, 315
Latin America, 348
Lea, Mathew C., 98
Le Bon, Gustave, 99
Lecuyer, Raymond, 42
Lefuel, Hector M., 379
Le Gray, Gustave, 100, 369
Legros, Adolphe, 101, 102
Lejko, Krystyna, 380
Leroy, Jean, 194
Le Secq, Henri, 369

Library of the Royal Academy of Fine
 Arts (Copenhagen), 347
Liebert, Alphonse, 340
Lincoln, Abraham, 212
Litchfield, R.B., 338
London, 322, 344, 352
Lothrop, Eaton S., Jr., 121
Ludgers, Ferdinand, 409
Luynes, Honore T., 280
Lyman, Christopher M., 225
Lyman, Susan B., 364

MacDonnell, Kevin, 274
MacLeod, Innes, 361
MacPherson, Robert, 398
magic lanterns, 169-175, 393
Mangan, Terry W., 381
Marbot, Bernard, 3
Marcy, Lorenzo J., 172
Marder, Estelle, 43
Marder, William, 43
Marks, W.D., 275
Martin, Paul, 268-270
Martinez, Romeo, 195
Marville, Charles, 206
Mathews, Oliver, 44
Matsura, Frank, 271
Mayer et Pierson (Paris), 45
Mayer-Wegelin, Eberhard, 382
McClelland, James, 383
McLuhan, T.C., 224
Mentienne, Adrien, 159
Meredith, Roy, 211-213
Meserve, Frederick H., 210
Mestral, O., 369
Meteyard, Eliza, 339
Metropolitan Museum of Art (New York), 3
Mexico, 220
Meyer, Bertrand, 327
Meyer, Catherine, 327

microscopic photography, 104
Middleton, C.S., 236
Milhollen, Hirst D., 384
Miller, Alan C., 214
Miller, Francis T., 385
Miller, Helen M., 263
Moigno, Francois N., 173
Monckhoven, Desire von, 103, 123, 124
monographs on photographers, 191-339
Morgan, Lewis H., 256
Moscow, 386
Mount Holyoke College Art Museum (South
  Hadley, MA), 398
Mountbatten, Earl of Burma, 400
Mugridge, Donald H., 384
Musee Reattu (Arles), 281
Museum of the City of New York, 296
Museum of Fine Arts (Houston), 115
Musulin, Janko, 374
Muybridge, Eadweard J., 272-277, 354
Myers, Eveleen, 187

Nadar, see: Tournachon, Gaspard F.
Nadar, Paul, 323
Naef, Weston J., 3, 31
National Gallery of Art (Washington, D.C.),
  62
National Portrait Gallery (Edinburgh),
  252, 254
Neff, Peter, 134
negative processes, see: albumen processes,
  calotypes, collodion processes, gelatin
  emulsion processes
Negre, Charles, 278-281
Netherlands, 353, 356
Nevins, Allan, 299
New England, 387
New Orleans, 390
New York, 349, 363
New York Historical Society, 349

New York Public Library, 142
Newhall, Beaumont, 19, 43, 46, 47, 57, 109,
  160, 265, 290
Newhall, Nancy, 237, 290
Nicholls, James, 104
Niepce, Claude, 285
Niepce, Isadore, 283
Niepce, Joseph N., 20, 51, 152, 159, 282-
  286, 363
Niepce de Saint Victor, Claude, 105
Niewenglowski, Gaston-Henri, 143
Niklewska, Jolanta, 380
Nostitz, Grigorii I., 386
Notman, William, 287, 402

Ogle, Thomas, 373
O'Sullivan, Timothy, 288-292, 354, 384
Oregon, 214, 335
Otte, Joachim, 188
Ovenden, Graham, 48, 49, 218

P.& D. Colnaghi & Co. (London), see:
  Colnaghi
Palestine, 242, 244, 246, 280, 362
Pare, Richard, 404
Paris, 340, 346, 379, 392
Partnow, Elaine, 5
Peters, Ursula, 50
Petit Palais (Paris), 3
Philadelphia, 164
photogenic drawing, see: calotypes
photographic processes, 11, 13;
  see also names of specific processes
Photographic Society of London, 60
photography as a fine art, 187, 188
physionotrace, 111
pictorial photography, 189, 190, 300-302
Pizzighelli, Giuseppe, 178
platinotypes, 176-178
Poland, 380

Ponti, Carlo, 398
Poole, Julia E., 2
Poole, Mrs., 242, 244
Poole, Reginald S., 242, 244
positive processes, see: carbon processes,
  daguerreotypes, platinotypes
Potonniee, Georges, 51, 228
Pougetoux, Alain, 195
Powell, Tristam, 215
Price, Lake, 52
Prinet, Jean, 332
Pringle, Andrew, 187
Pritchard, H. Baden, 53, 54, 168

Quennell, Peter, 55
Queslin, Amedee, 161

Rabending & Von Monckhoven, see:
  Monckhoven, Desire von
Rejlander, Oscar, 218, 293, 294
Richebourg, A., 162
Riis, Jacob A., 295-299
Rinhart, Floyd, 163
Rinhart, Marion, 163
Rintoul, A.N., 144
Ritchie, Anne T., 216
Robertson, James, 239
Robinson, Henry P., 180, 187, 190, 300-
  302
Robiquet, Edmond, 106
Roegiers, Patrick, 405
Rodgers, H.J., 56
Rome, 395
Roosevelt, Theodore, 223
Root, Marcus A., 57
Rosenblum, Naomi, 406
Royal Library, Copenhagen; Department of
  Maps and Prints, 347
Russell, Andrew J., 303, 304
Russia, 394

San Antonio, 393
Sandler, Martin W., 387
Sarony, Napoleon, 304, 305
Sawyer, Lyddell, 187
Schiller, Ely, 388
Schulze, Johann H., 18
Schwarz, Heinrich, 253
Scotland, 35, 345, 361, 371, 399
Scovill, James, 38
Scovill, William, 38
Seddon, John P., 389
Sedgfield, W. Russell, 373, 396
Seele, Carl W., 18
Seligman, Edwin R., 232
Sella, Venanzio G., 107
Sequin, Jean-Pierre, 3
Shaw, Bill E., 309
silver processes, 179, 180;
  see also: calotypes, daguerreotypes
Simons, Montgomery P., 145, 164
Simpson, George W., 146
Smith, Adolphe, 322
Smith, Hamilton, 134
Smith, Margaret D., 390
Smithsonian Institution (Washington, D.C.),
  225
Smyth, Charles P., 391
Snelling, Henry H., 58, 59
Snyder, Joel, 291
Sobieszek, Robert A., 307
Societe Francaise de Photographie (Paris),
  60, 286
Societe Heliographique (Paris), 369
Societe Imperiale des Science, de l'Agri-
  culture et des Arts de Lille, 204
Sougez, Emmanuel, 61
Soule, John P., 375
Soulier, Charles S., 392
Southworth, Albert S., 306, 307
Sprague, Marshall, 264

Stapp, William F., 62
Steinfeldt, Cecilia, 393
Stenger, Erich, 64, 229
stereoscopic photography, 10, 181-184, 357, 365
Stevens, Thomas, 394
Stevenson, Sara, 254
Steves, Albert, 393
Steward, Julian H., 257
Strasser, Alex, 65
Strauss, G.L., 92
Strong, Roy, 8, 252
Sturmey, Henry, 174
Suffling, Ernest R., 267
Sutcliffe, Frank M., 187, 308-310
Sutton, Thomas, 63, 117, 203, 372
Swan, Joseph W., 356
Switzerland, 368
Symonds, J.A., 187
Szarkowski, John, 197

Taft, Robert, 66
Talbot, William H., 311-317
Taunt, Henry W., 318-320
telephotography, 83
Tennyson, Alfred, 216
Thierry, J., 165
Thomas, Alan, 67
Thomas, Alexander, 401
Thompson, S., 373
Thomson, John, 68, 321-322, 363, 372
Thornthweite, William H., 108
Thorvaldsen Museum (Copenhagen), 395
Tilden, Freeman, 249
tintypes, 185, 186
Tissandier, Gaston, 68,69
Tong, James Y., 95
Tournachon, Gaspard F., 323-332, 346
Towler, John, 109
Trask, Albion K., 186
Triggs, Stanley, 287

Tubbs, D.B., 118
Tucker, Mary L., 390
Turner, Peter, 238

United States, 66, 72, 75, 160, 163,
    183, 354

Valicourt, E. de, 110
Van Haaften, Julia, 246
Van Nostrand, Jeanne, 333
Vance, Robert H., 333, 334
Victoria and Albert Museum (London), 37
Vidal, Leon, 125, 147
Vignes, Louis, 280
Virginia, 376
Vitali, Lamberto, 332
Vivarez, Henry, 111
Vogel, Hermann W., 112-114, 148

Waldack, Charles, 134
Wales, 201, 357
Wall, Alfred H., 149, 293
Wall, Edward J., 70, 142
Ware, James R., 396
Ware, Louise, 299
Warner, John, 397
Watkins, Carleton E., 335-337, 354, 363
Watson, Wendy M., 398
Weaver, Mike, 407
Wedgwood, Thomas, 338-340
Weed, Charles L., 358, 404
Welford, Walter D., 174
Welling, William B., 71, 72
Wellington, J.B., 187
Werge, John, 73
White, Jon E., 246
Wilkinson, B. Gay, 187
Wilson, Edward L., 74, 126, 175, 373
Wilson, George W., 399
Wolf, Daniel, 75

Wood, Richard, 238
Woolf, Virginia, 215
Worden, John, 63
World's Columbian Exhibition, 1893
  (Chicago), 266
Worswick, Clark, 400
Wurttembergischer Kunstverein Stuttgart,
  277

Ziebarth, Marilyn, 337
Zuchold, Ernst A., 407